YESTERDAY'S
TOYS
Robots, Spaceships, and Monsters

YESTERDAY'S TOYS

Robots, Spaceships, and Monsters

Teruhisa Kitahara ▪ Photography by Masashi Kudo

Chronicle Books ▪ San Francisco

First published in the United States in 1989 by Chronicle Books.

Library of Congress Cataloging in Publication Data:

Kitahara, Teruhisa, 1948–
 [Yesterday of toys. SF & robots]
 Yesterday's toys. Robots, spaceships, and monsters/Teruhisa
Kitahara; photographs by Masashi Kudō.
 p. cm.
 Originally published: Yesterday of toys. SF & robots. Tokyo,
Japan: Graphic-sha Pub. Co., ©1988.
 ISBN 0-87701-630-5
 1. Tin toys—Private collections—Japan—Catalogs. 2. Toys,
Mechanical—Private collections—Japan—Catalogs. 3. Kitahara,
Teruhisa—Art collections. 4. Robots—Catalogs. I. Kudō, Masashi.
II. Title.
TS2301.T7K477 1989
688.7'28—dc20 89-17352
 CIP

Printed in Japan.

Cover design by Julie Noyes

Distributed in Canada by
Raincoast Books
112 East Third Avenue
Vancouver B.C. V5T 1C8

10 9 8 7 6 5 4 3 2 1

Chronicle Books
275 Fifth Street
San Francisco, California 94103

YESTERDAY'S TOYS—OBJECTS OF WONDER

Robots and other science-fiction-related toys were always objects of wonder to children. Even the simplest spring-operated robot looks powerfully mechanical to young eyes.

The word *Robot,* referring to an artificial humanoid, first appeared in the drama *R.U.R.,* written by Czechoslovakian author Karel Capek in 1920. But it is not clear when robots made their first appearance as toys. There seem to have been mobile, doll-like toys for quite some time, but these were not actual robots.

Toy robots reached their height of popularity from the 1940s to the 1960s. This can be said for tinplate toys in general; they all experienced their peak during this period. The archetypal robot of the era was Robby. Robby was introduced in 1956, when he appeared in Metro-Goldwyn-Mayer's science-fiction movie *The Forbidden Planet.* This film tells the story of a scientist who was shipwrecked for years on another planet, where he created a robot called Robby, a machine with a human personality, who could speak human language, had feelings, and could even eat if he wanted to. From this character, the toy Robby was created. Although toy robots varied in size, means of movement, and materials, each robot had some of the characteristics of Robby.

Another famous robot was Goto, who was introduced in the Twentieth Century Fox movie *The Day the Earth Stood Still.* After these two prototypes, many other toy robots and spaceships became popular. There were a variety of kinds, from simple toys joining square parts of different sizes, to complicated toys with flashing lights and missile launchers on their fronts. The era of robot and science-fiction toys was also the era when manufacturing techniques were progressing dramatically. Not only were there advances in mechanical techniques, but even the methods of printing on tin changed the world of toy robots, allowing the tiniest gauges and meters to be printed in detail.

In many of these toys, especially those made in Japan, we can see the influence of television and comic heroes such as Steelman and Astroboy. Many variations of these heroes were produced. Sometimes, to cut down production costs, robots were cast in the same molds and changed only by small printing details into different toys.

Robots and science fiction toys have undergone many changes and have now been surpassed in popularity by television and video games. But their futuristic shapes and materials have the perennial fascination of the new. The wonder and excitement of the unknown are always with us.

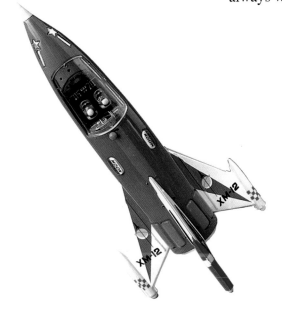

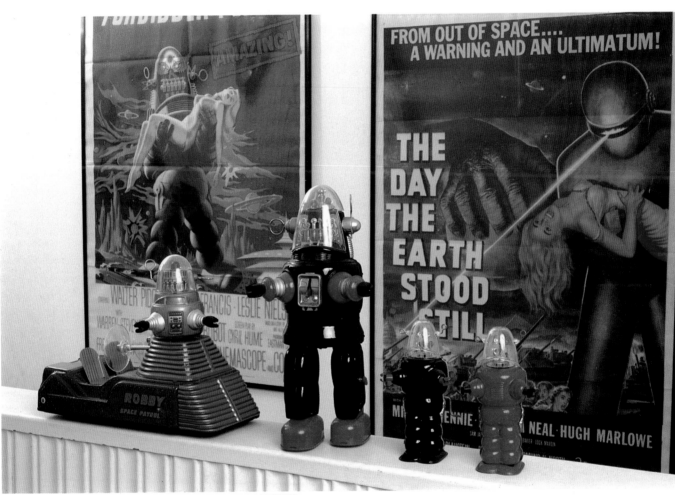

●1~●4 15×33×22.5, 17.5×13.5×31, 9×6.5×16/ NOMURA, YOSHIYA/B,F/1950'S

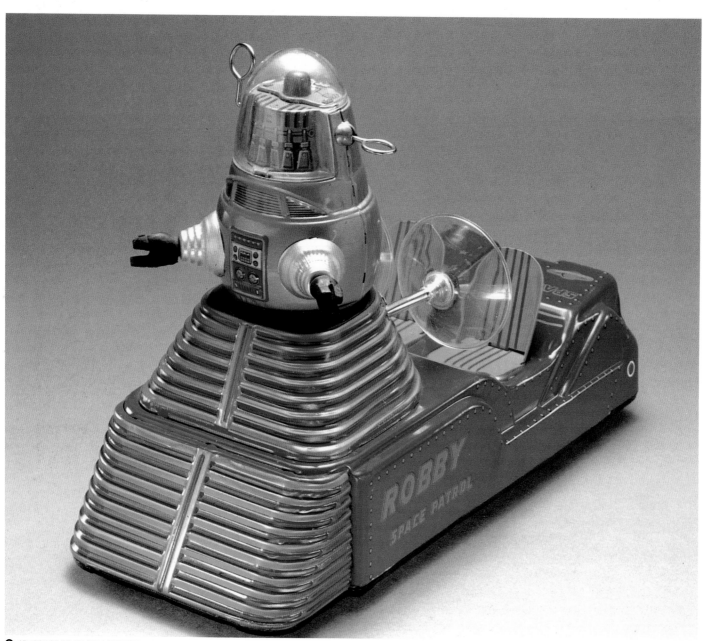

❺ 15×33×22.5/NOMURA/B/1950'S

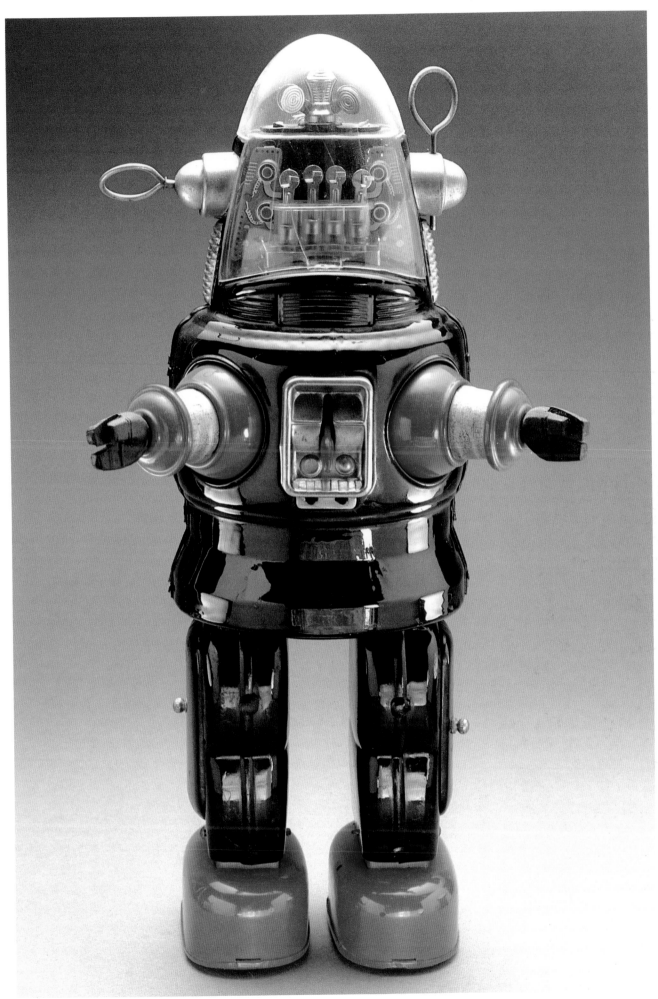

❻ 17.5×13.5×31/NOMURA/B/1950'S

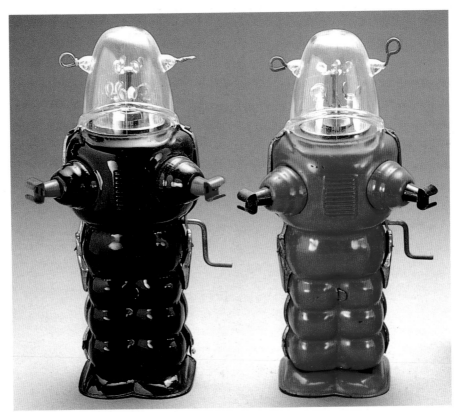

❼❽ 9×6.5×16/YOSHIYA/F/1950'S

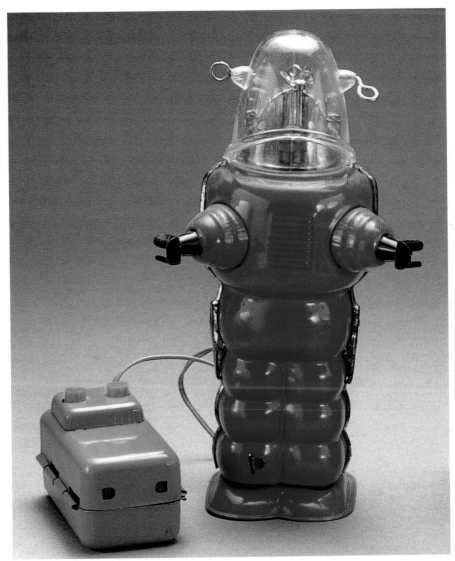

❾ 9×6.5×16/YOSHIYA/B/1950'S

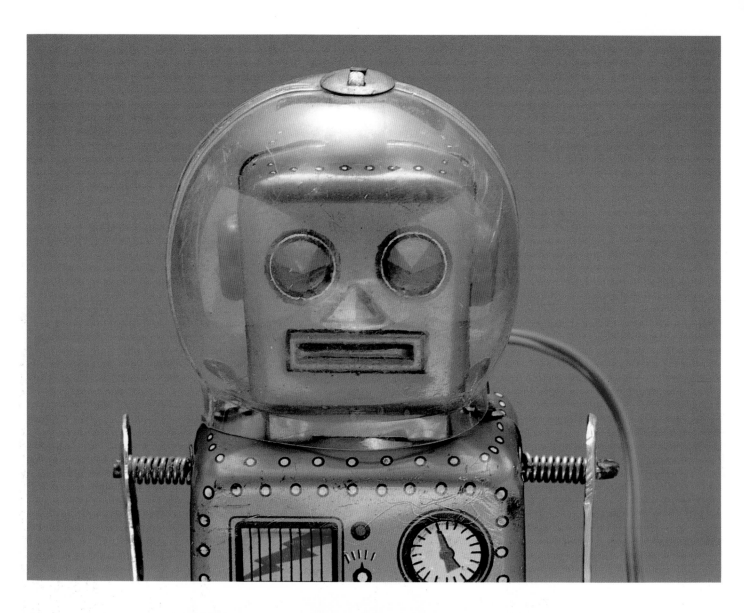

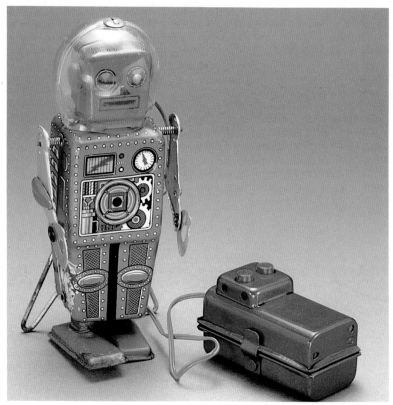

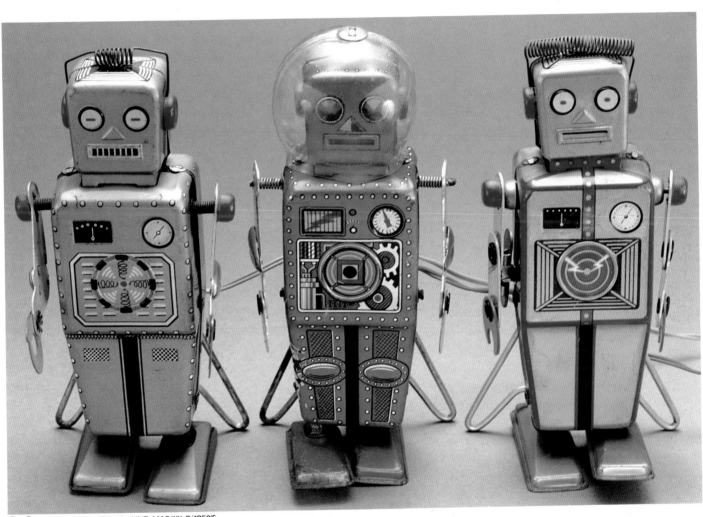

❿～⓬ 7×5.5×16/YONEZAWA, LINE MAR/W, B/1950'S

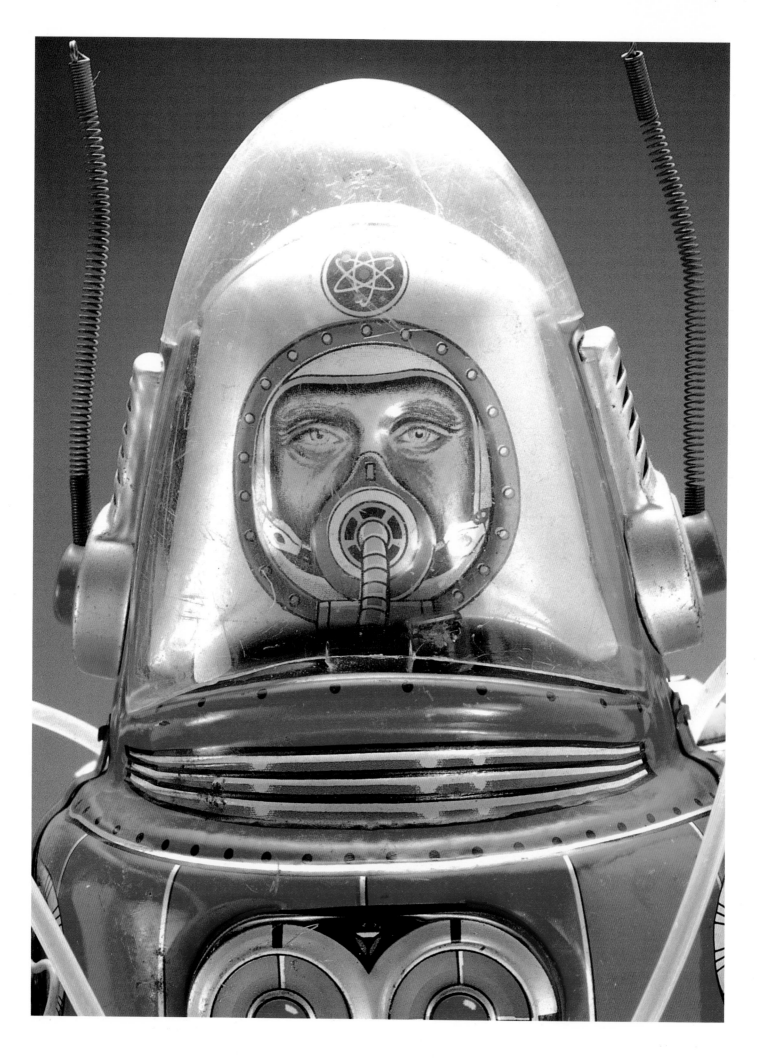

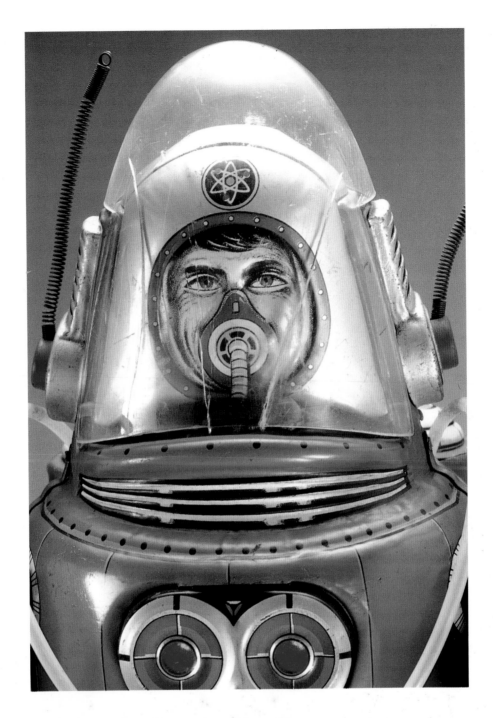

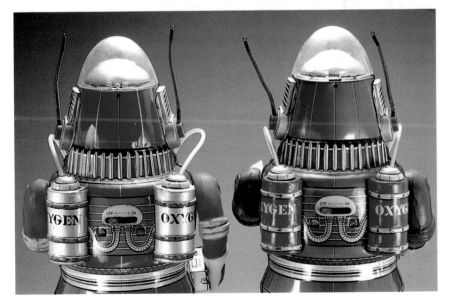

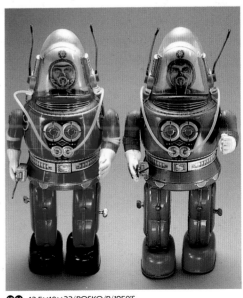

⑬⑭ 13.5×10×33/ROSKO/B/1950'S

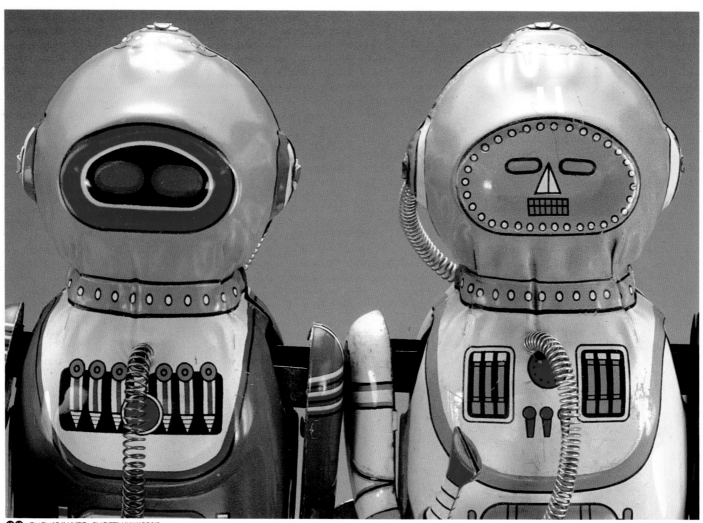

❶❺❻ 7×7×19/NAITO SHOTEN/W/1950'S

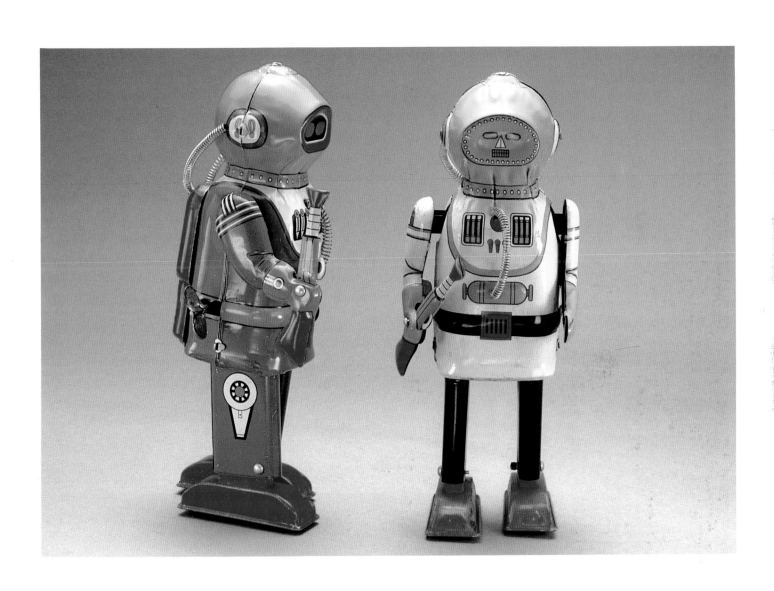

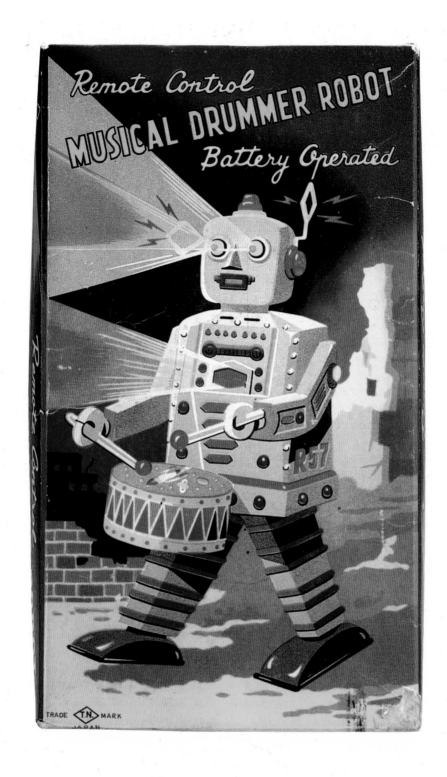

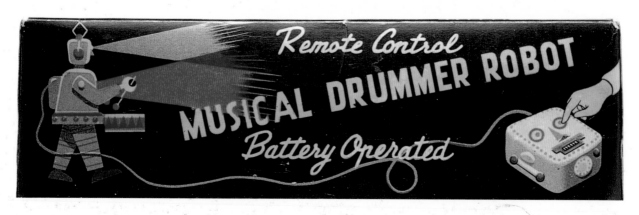

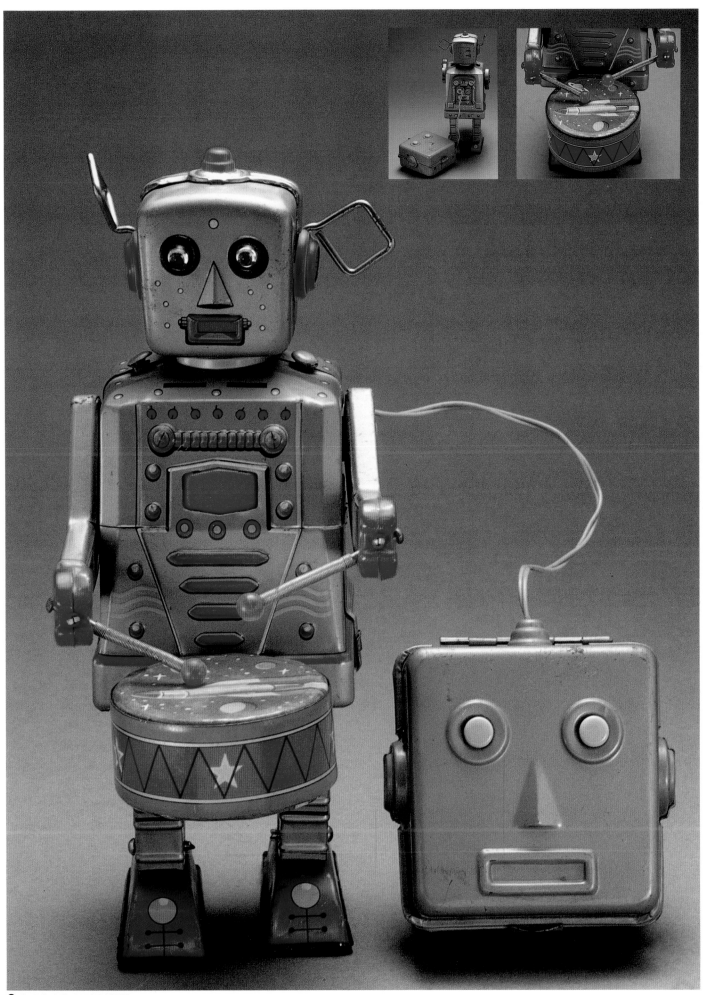

⓱ 9×14.5×21/NOMURA/1950'S

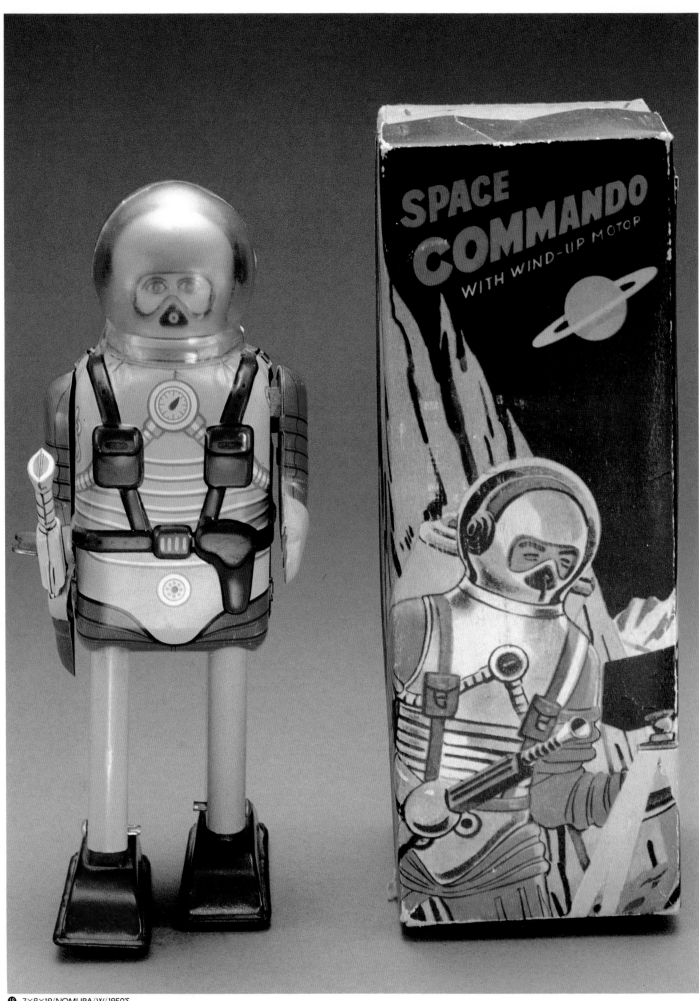

⑱ 7×8×19/NOMURA/W/1950'S

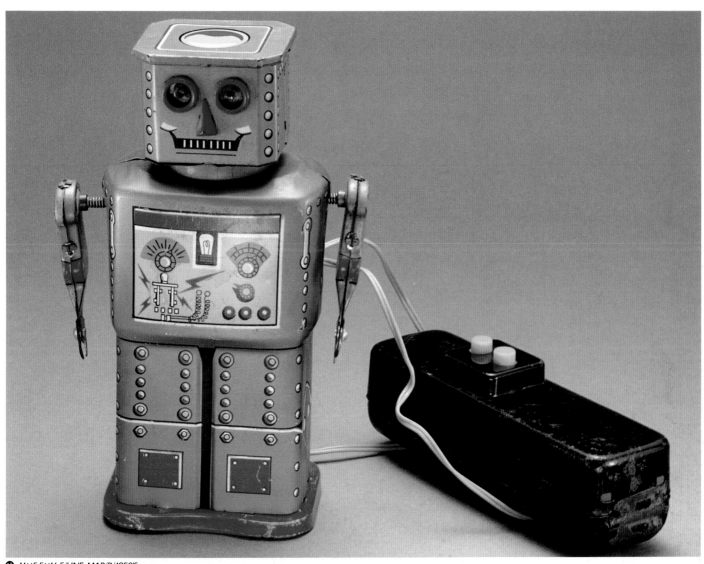

⓳ 11×5.5×16.5/LINE MAR/B/1950'S

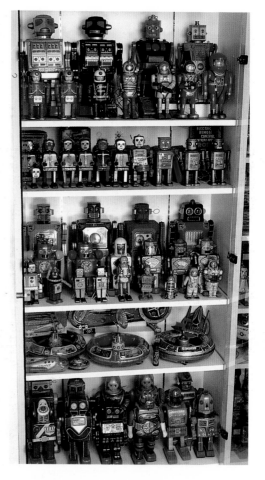

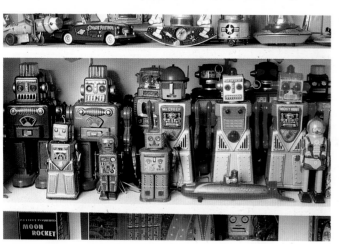

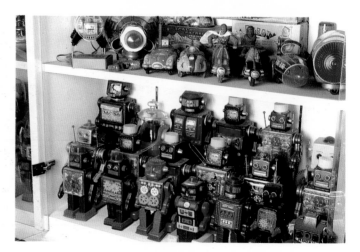

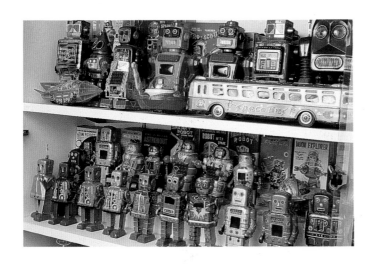

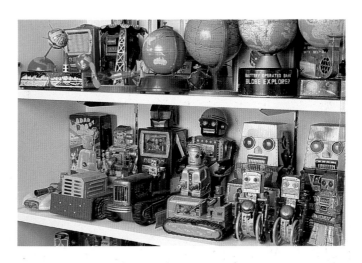

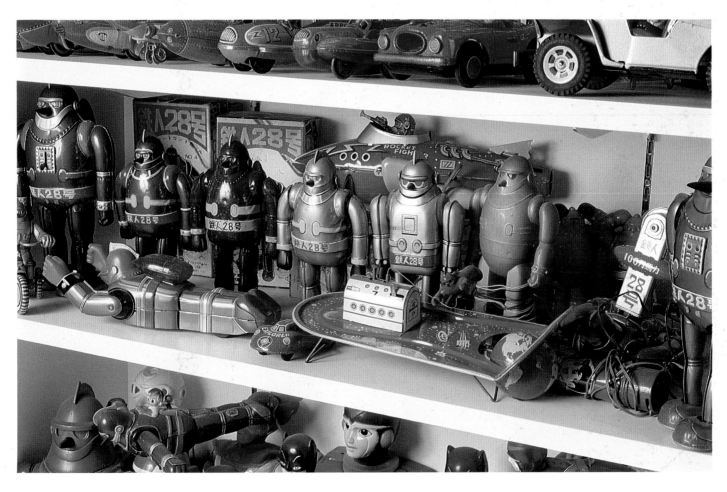

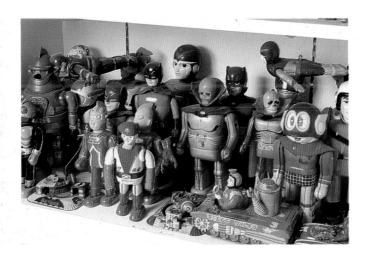

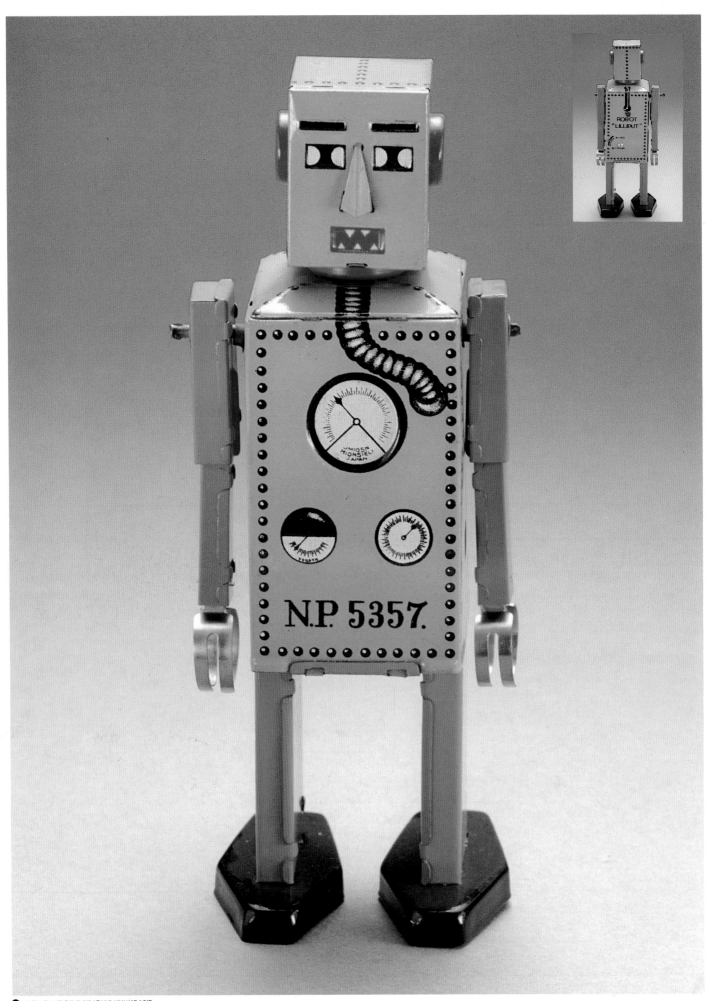

⑳ 6.5×5×15.5/UNKNOWN/W/1940'S

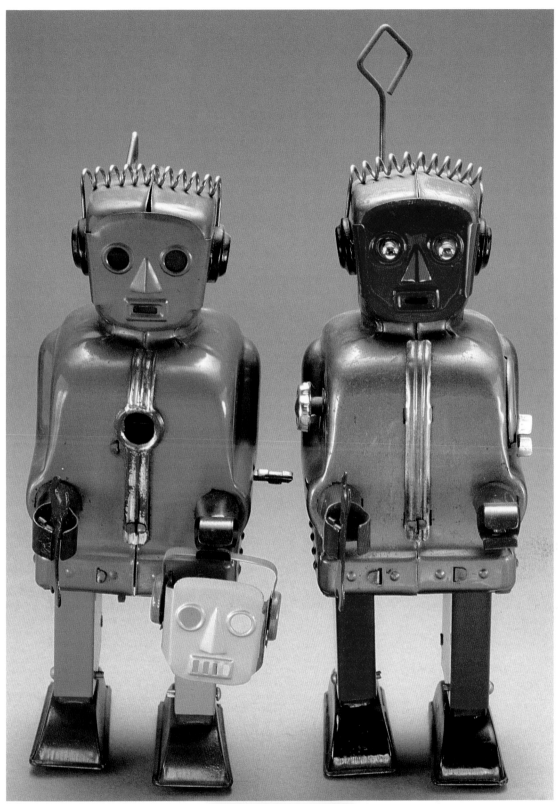

21·22 10×7×19/NOMURA/B, W/1950'S

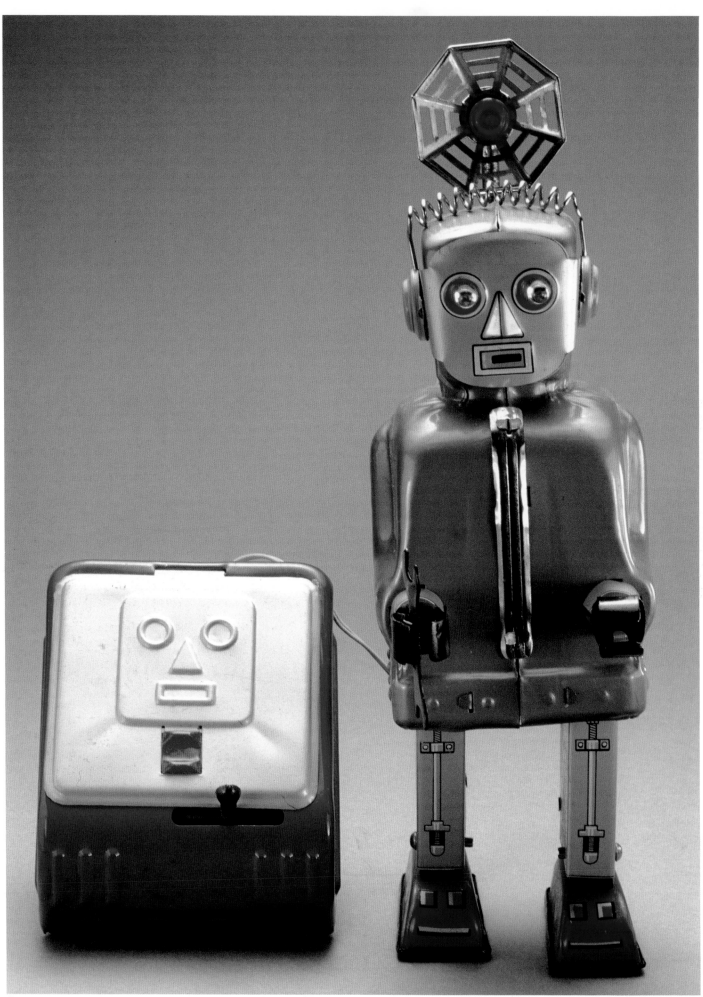

㉓ 7×10×24/NOMURA/B/1950'S

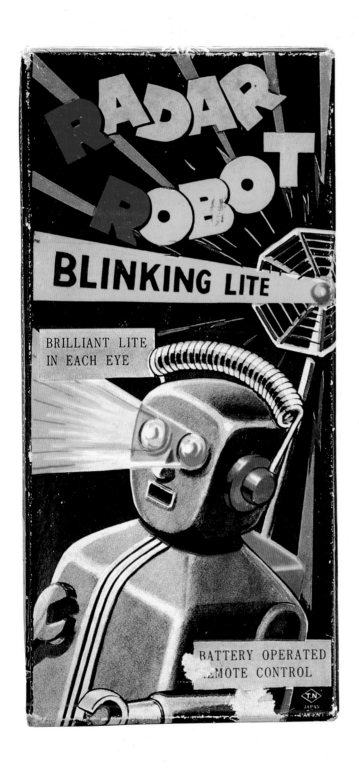

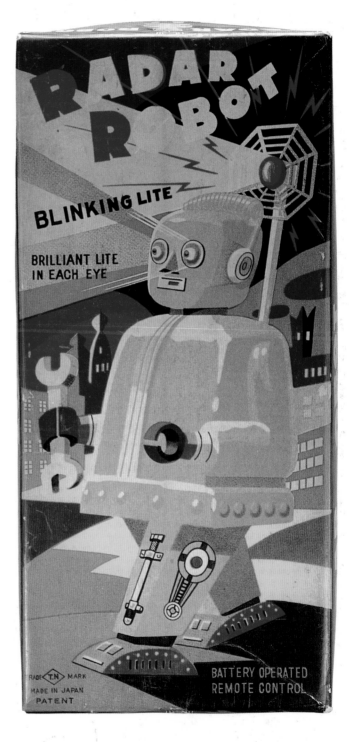

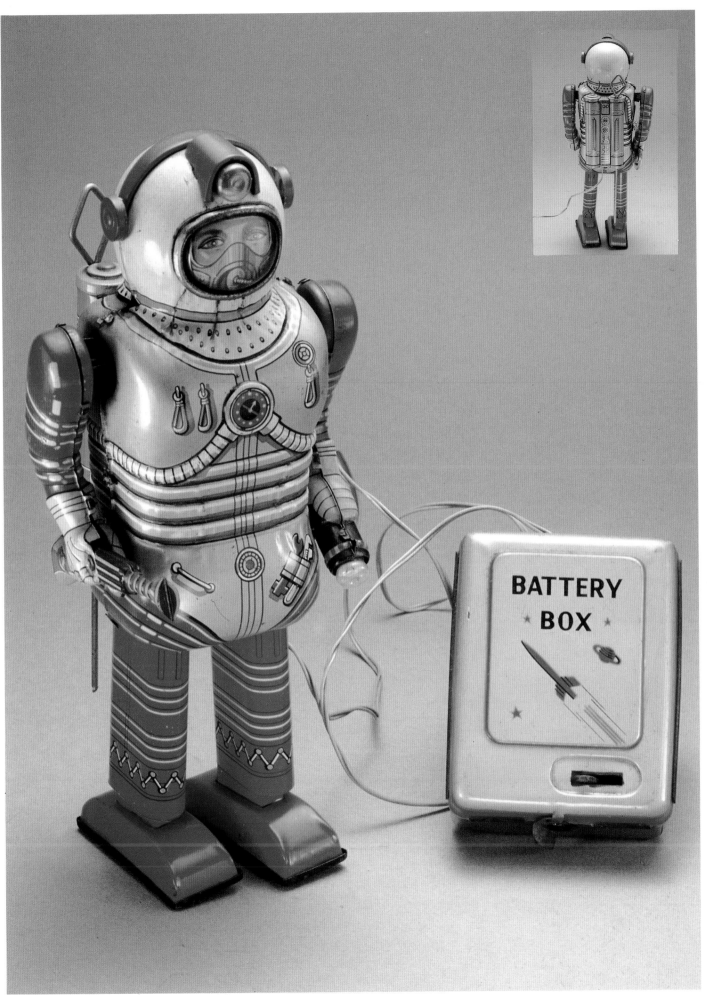

㉔ 10×8×22.5/NOMURA/B/1950'S

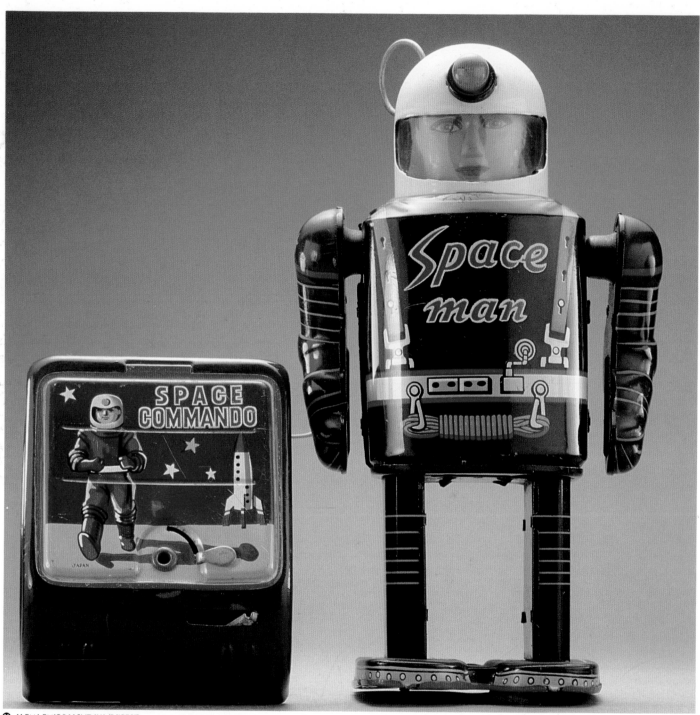

㉕ 11.5×6.5×19/MASUDAYA/B/1950'S

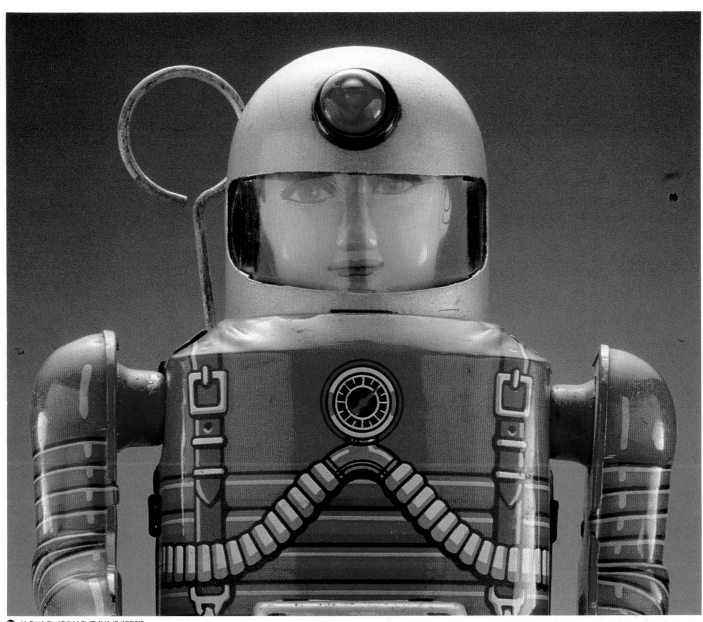

26 11.5×6.5×19/MASUDAYA/B/1950'S

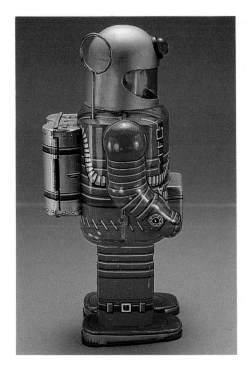 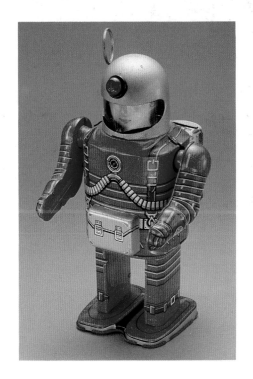

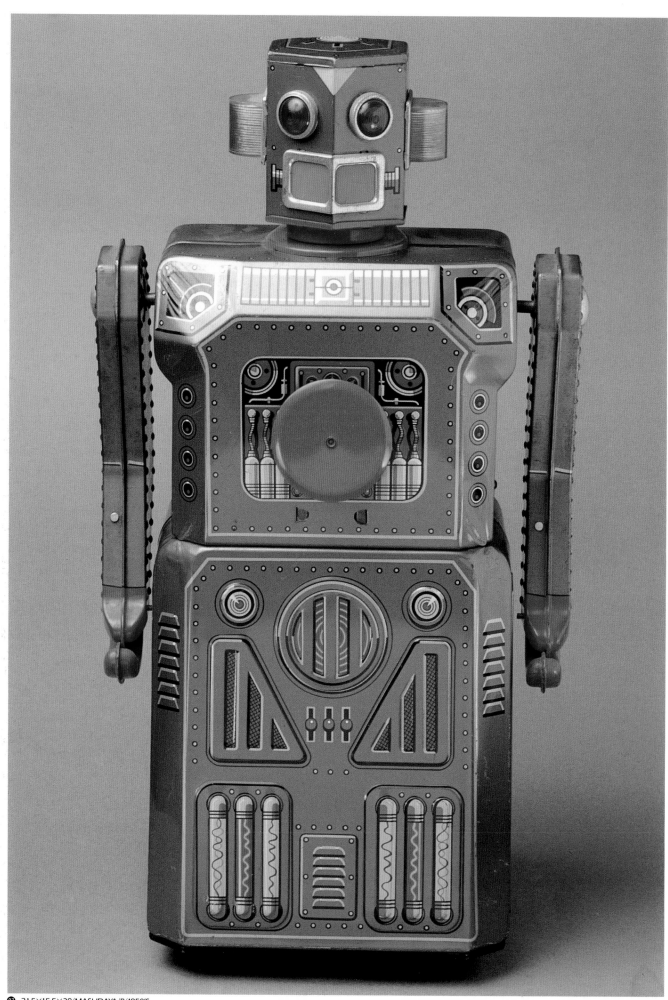

27 21.5×15.5×38/MASUDAYA/B/1950'S

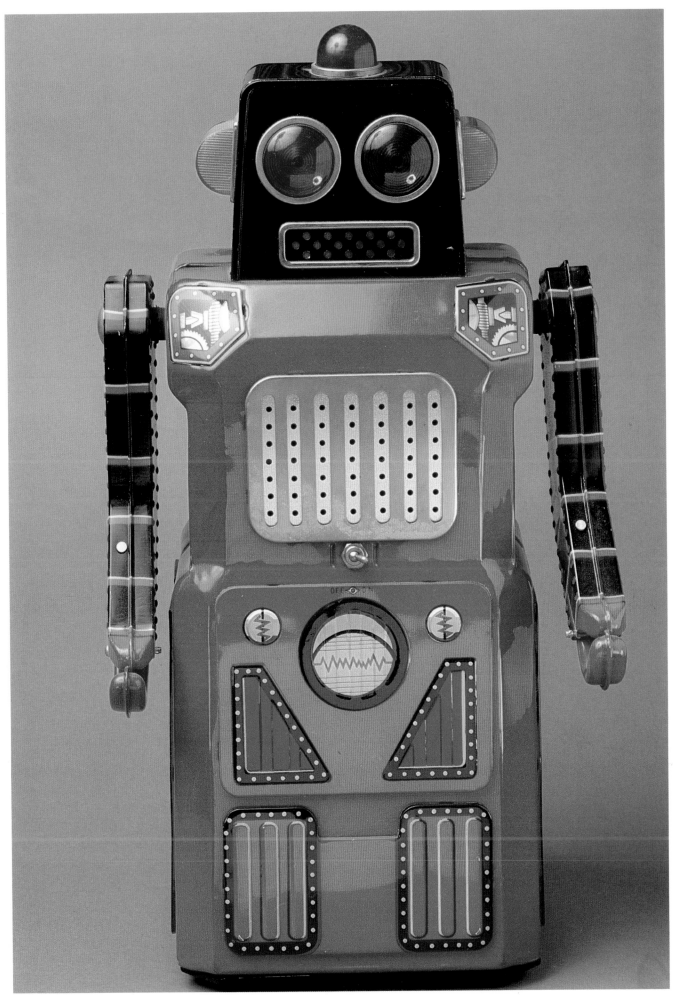

28 21.5×16×38/MASUDAYA/B/1950'S

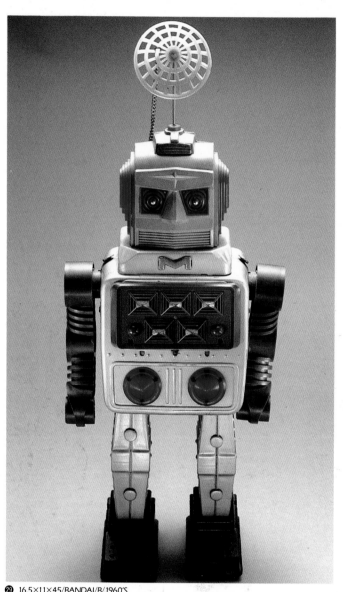

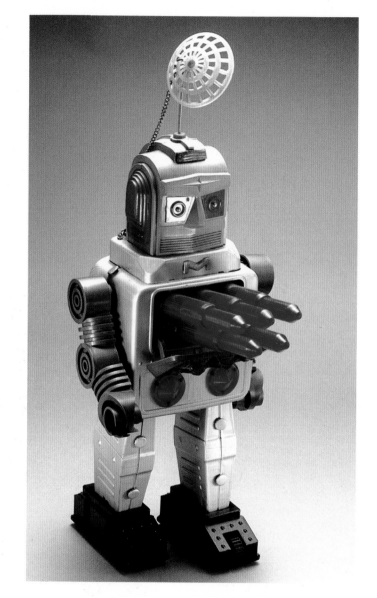

㉙ 16.5×11×45/BANDAI/B/1960'S

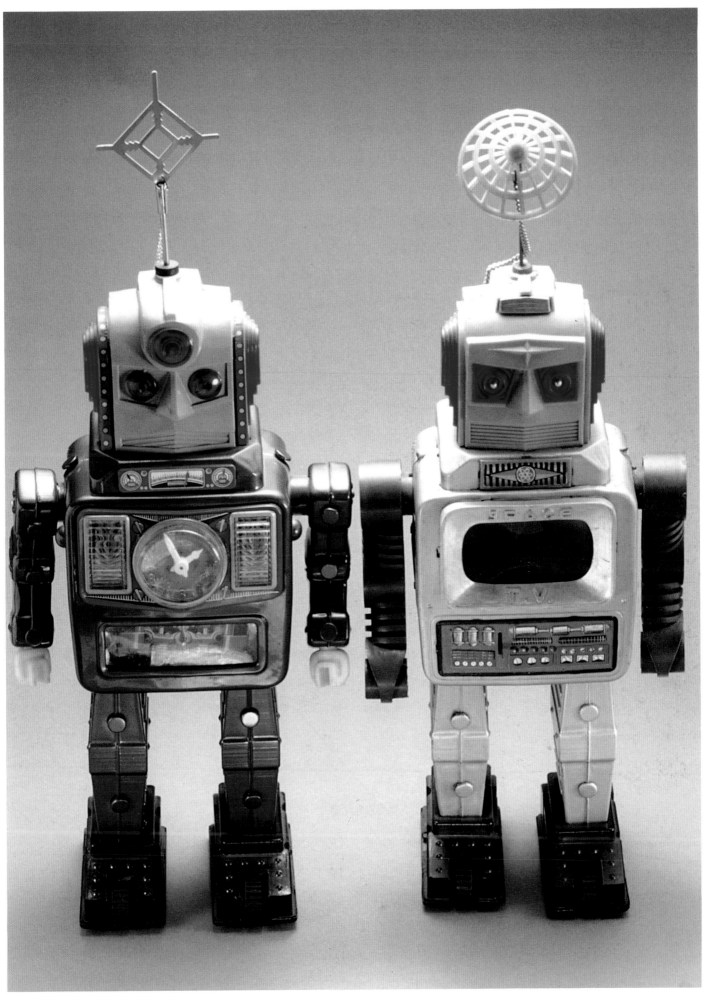

30 31 16.5×11×45/BANDAI/B/1960'S

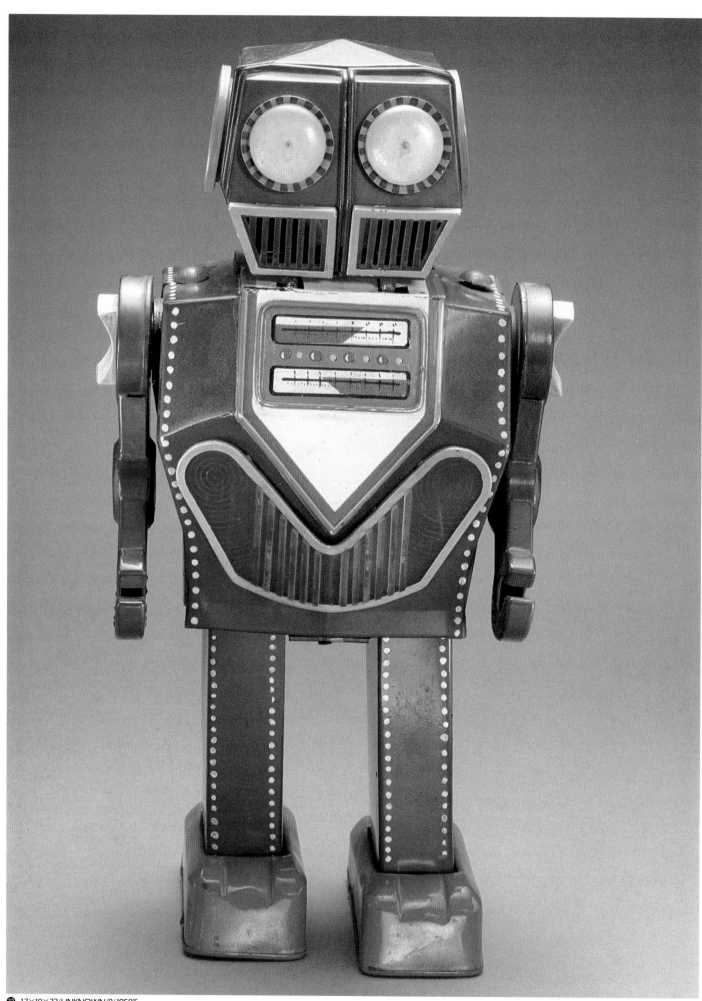

❸❷ 17×10×32/UNKNOWN/B/1950'S

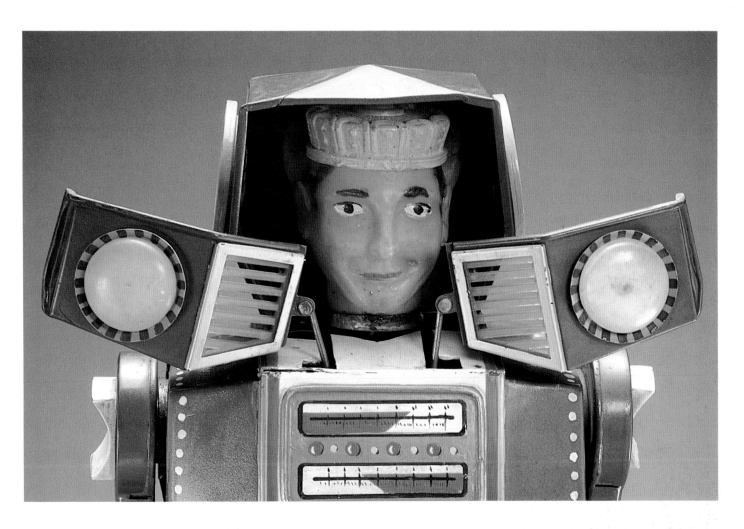

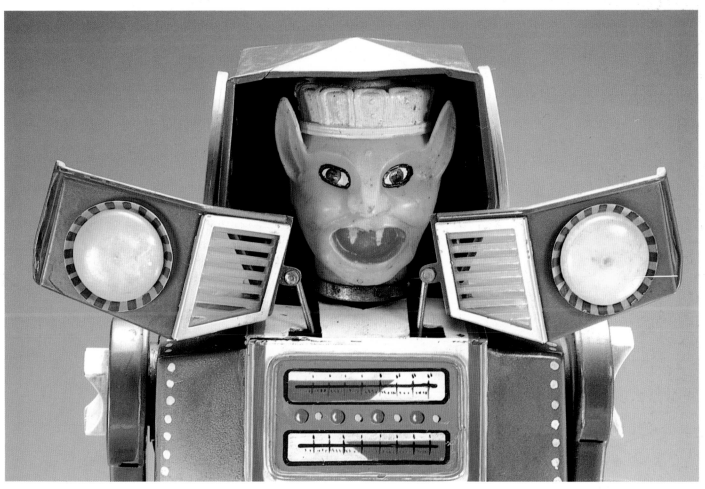

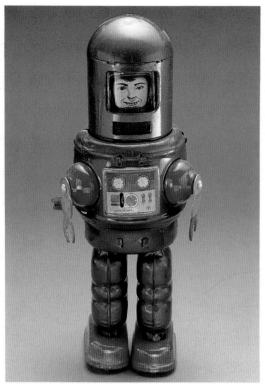

③ 9×8×22/YONEZAWA/W//1950'S

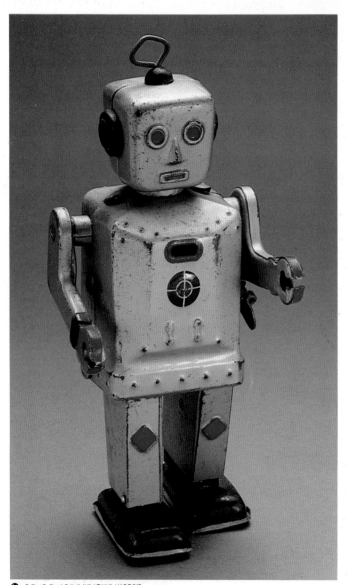

③ 8.5×8.5×19/UNKNOWN/1950'S

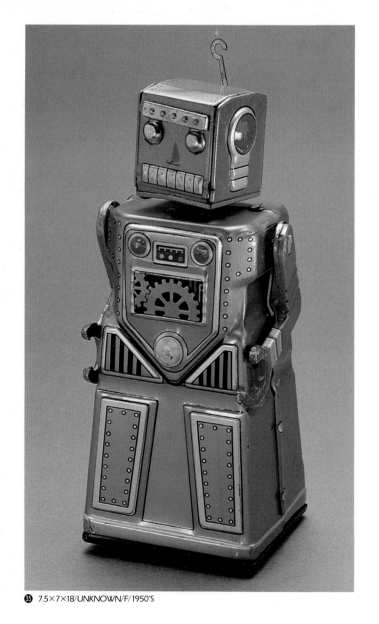

③ 7.5×7×18/UNKNOWN/F/1950'S

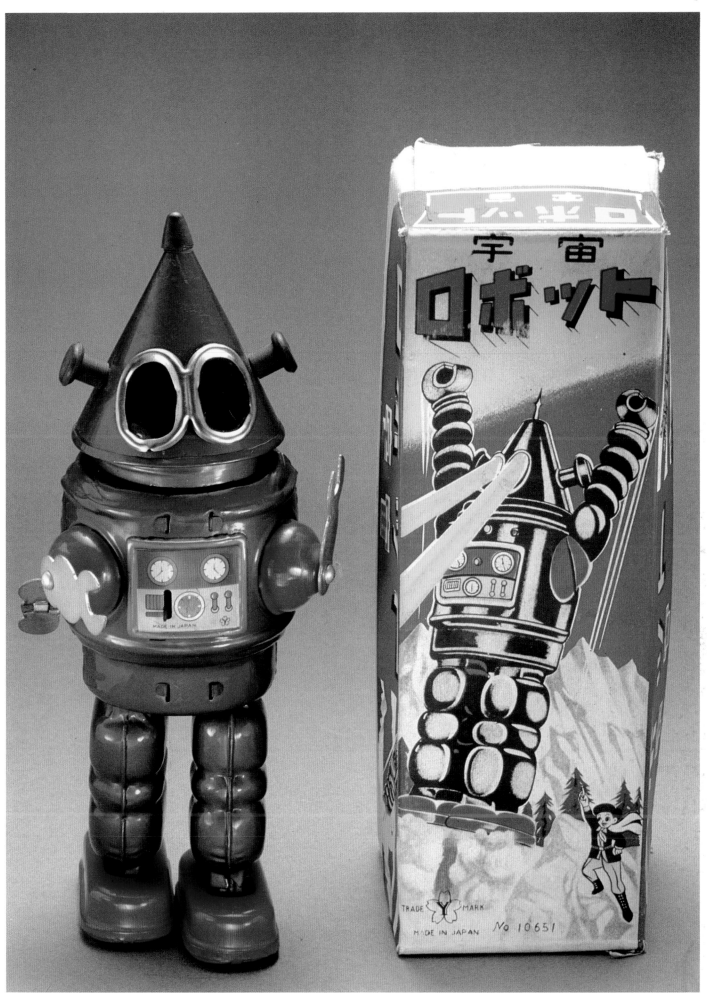

㊱ 7×8.5×21.5/YONEZAWA/W//1960'S

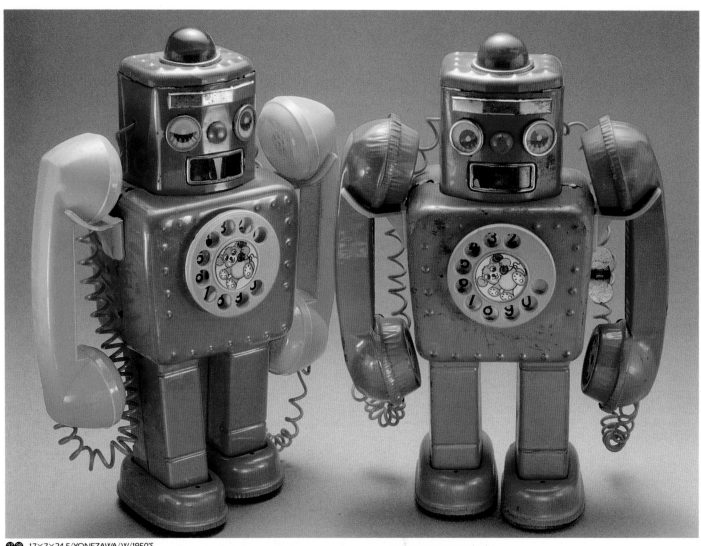

37·38 17×7×24.5/YONEZAWA/W/1950'S

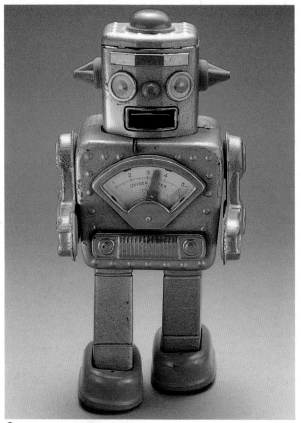

39 12×10.5×24/YONEZAWA/W/1950'S

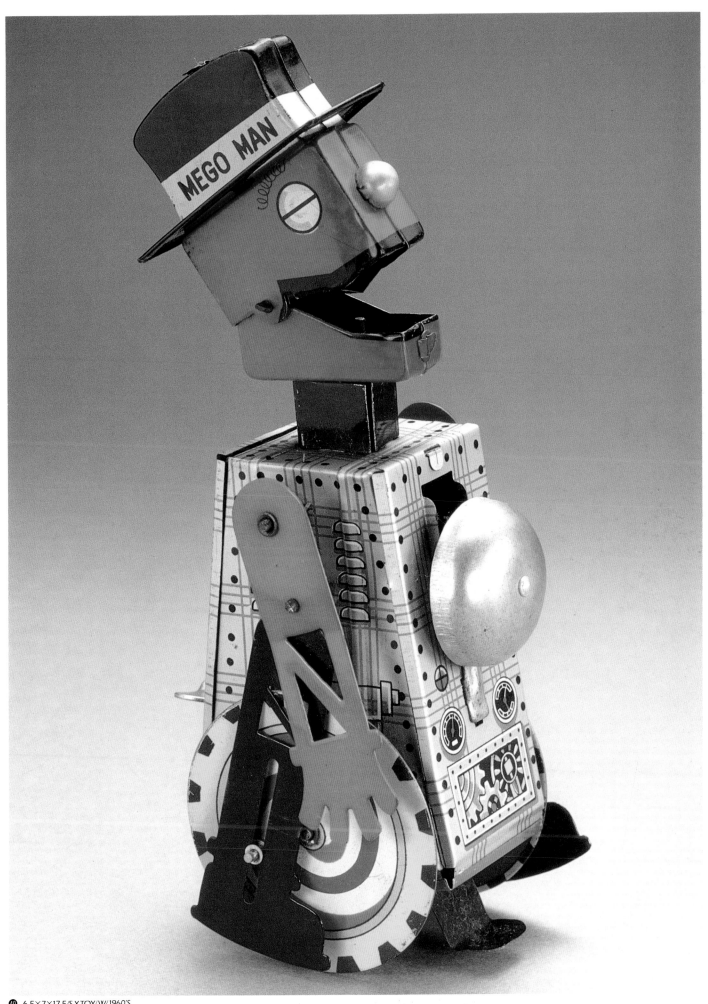

❹ 6.5×7×17.5/S.Y.TOY/W//1960'S

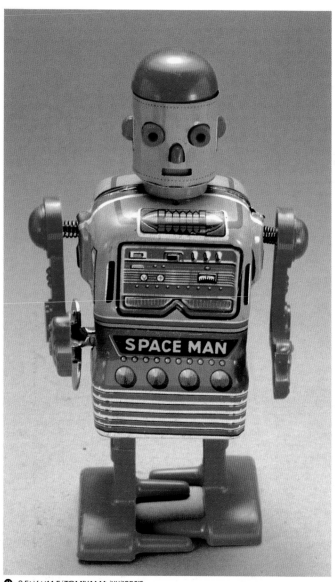

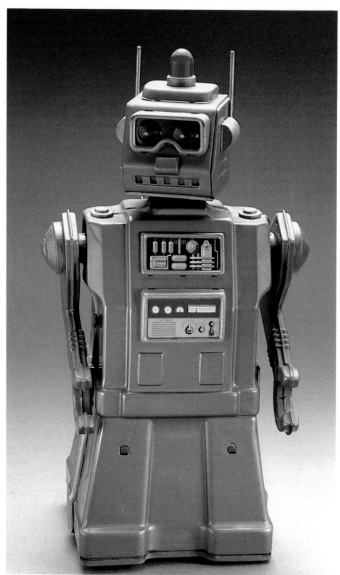

❹❶ 8.5×6×14.5/TOMIYAMA/W/1950'S

❹❷ 15×11.5×27.5/YONEZAWA/B/1950'S

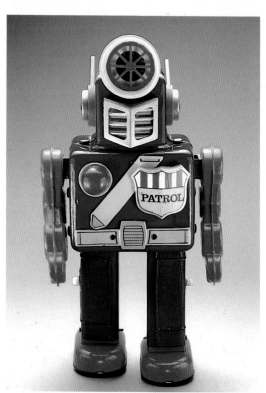

❹❸ 16×10×31/UNKNOWN/B/1950'S

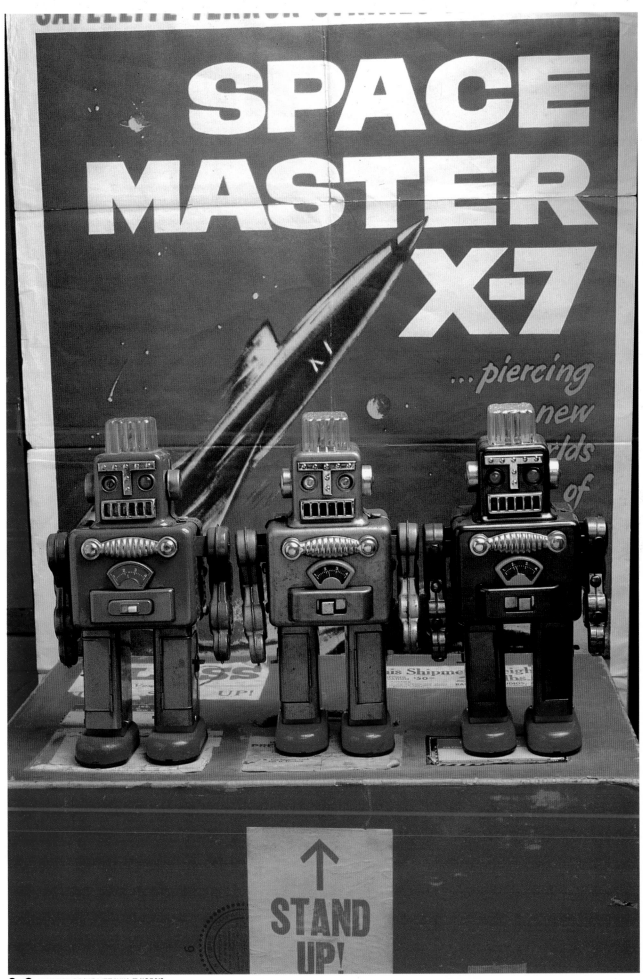

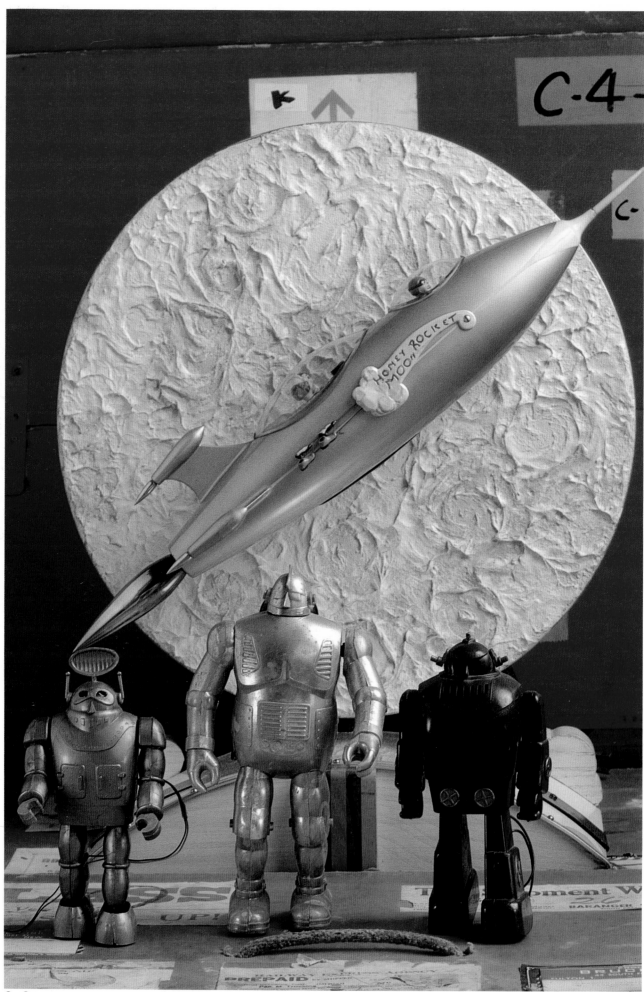

47~49 8×6×14, 9×8×21, 8.5×6×15/KOGURE/B/1960'S

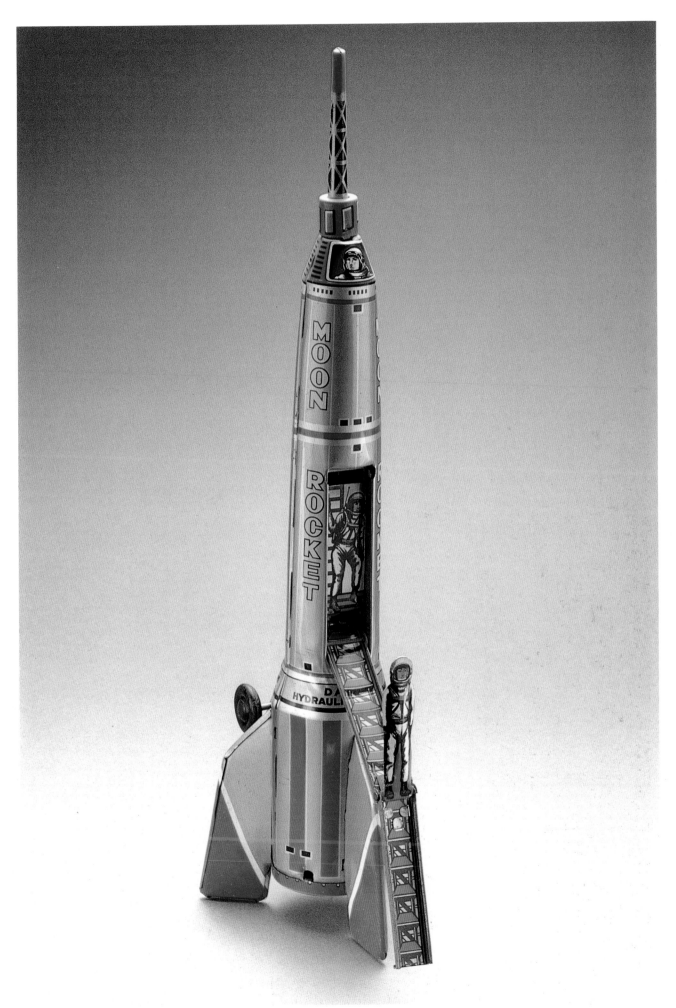

50 10×10×40/MASUYA/F/1960'S

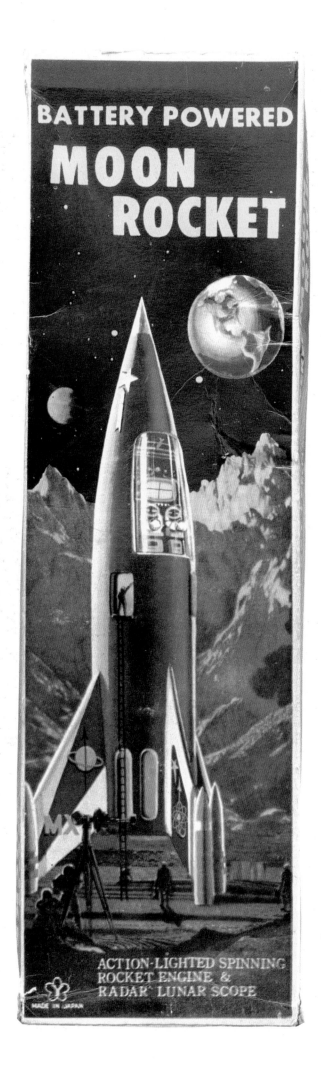

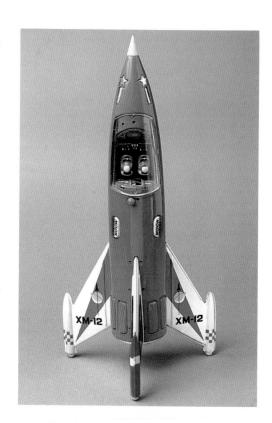

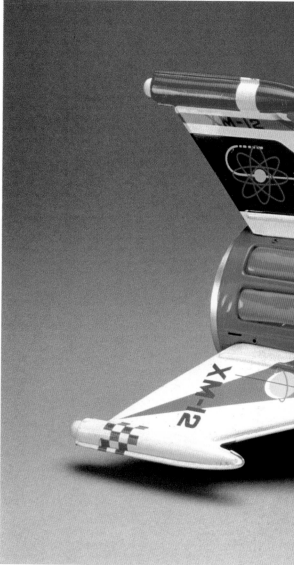

⑤ 18.5×39×14.5/YONEZAWA/B/1950'S

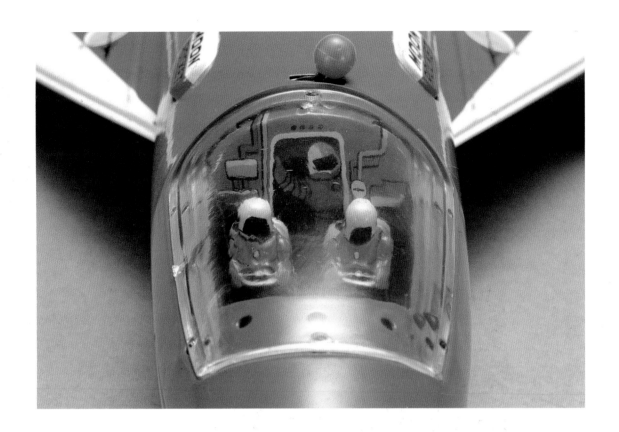

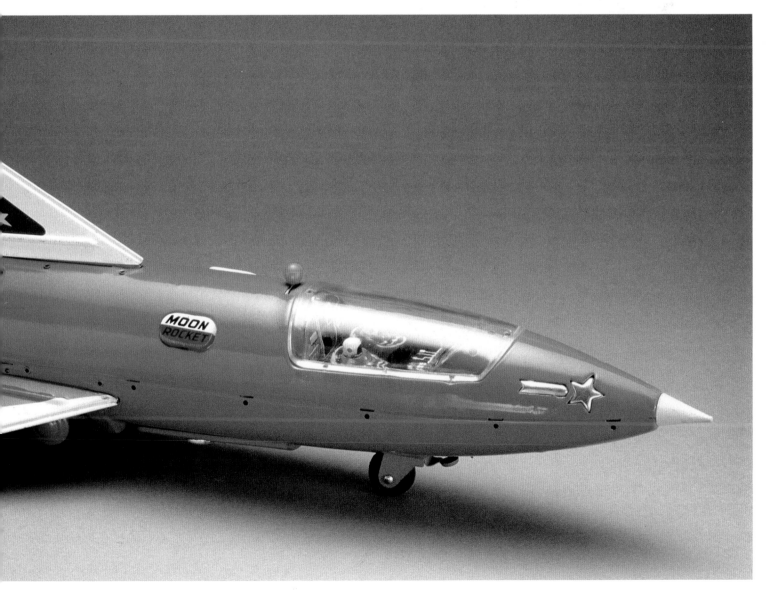

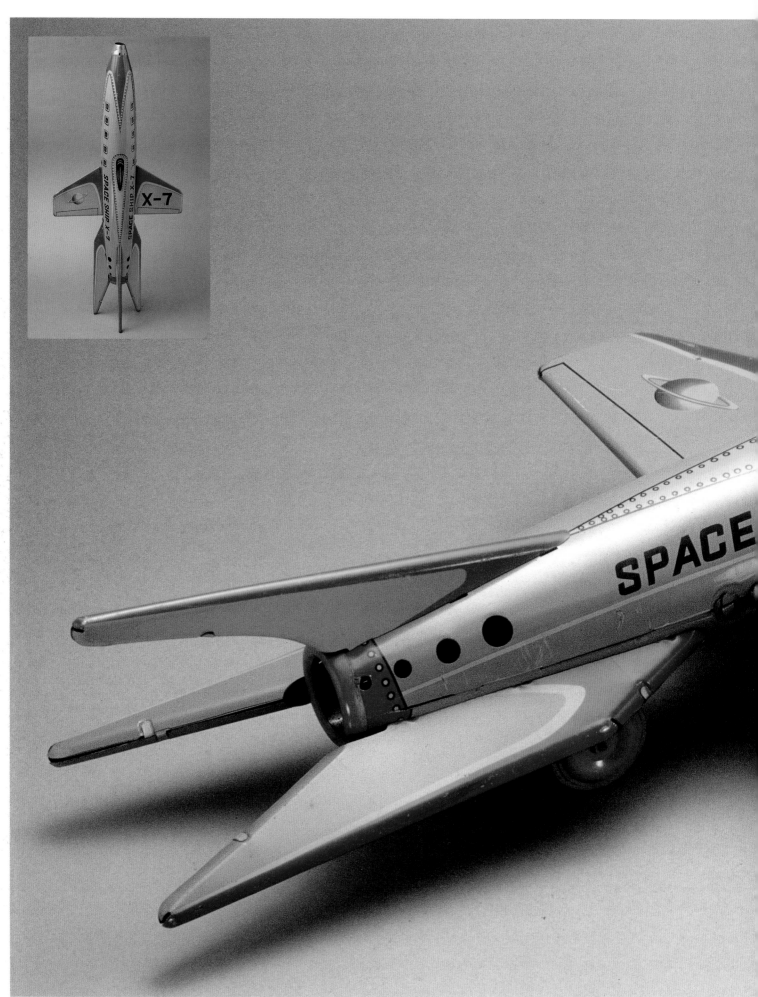

52 26×56×11/MASUDAYA/F/1950'S

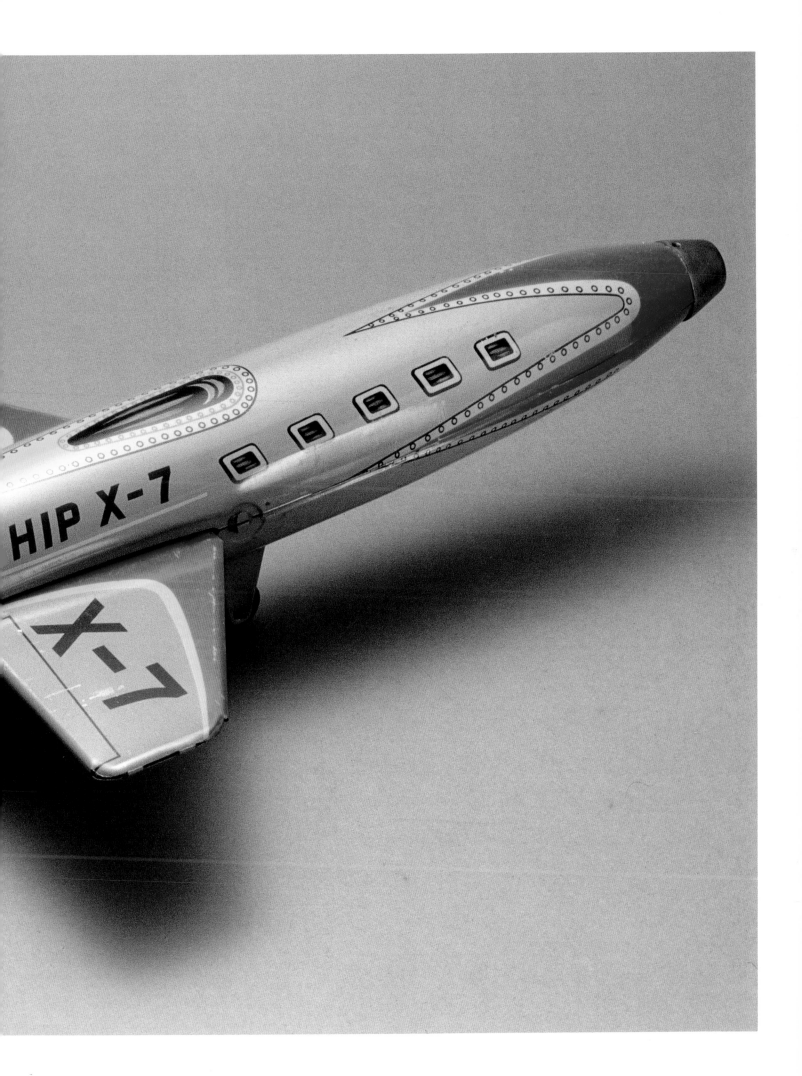

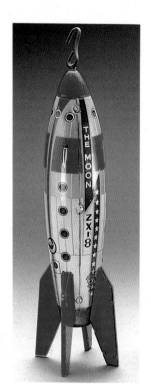

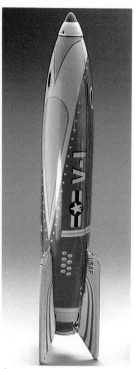

53 5.5×5.5×24/MARUSAN/F/1950'S

54 7×7×32/UNKNOWN/F/1950'S

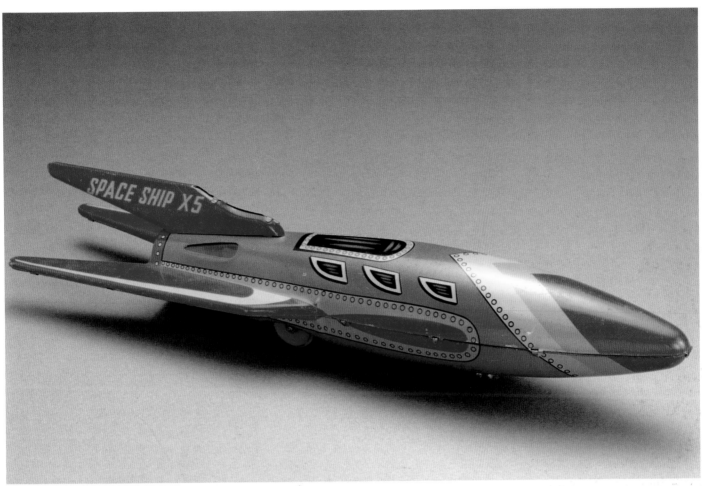

⑤⑤ 7×6×31/MASUDAYA/F/1950'S

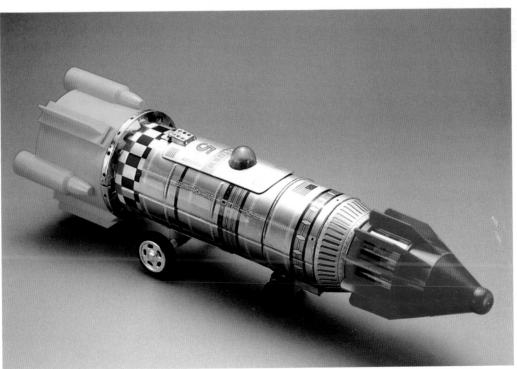

⑤⑥ 10×45×12/UNKNOWN/B/1960'S

53

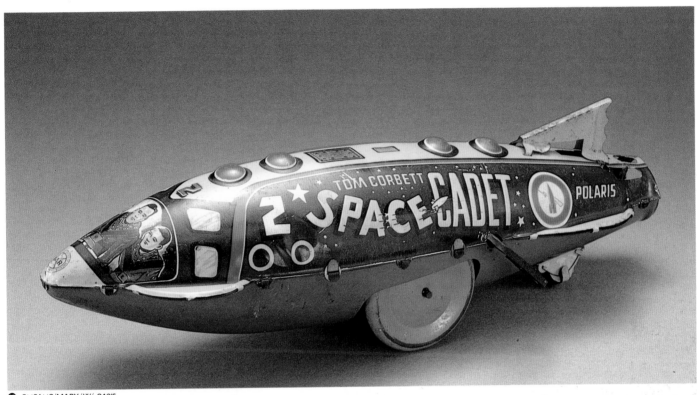

🔵 8×31×9/MARX/W/ 940'S

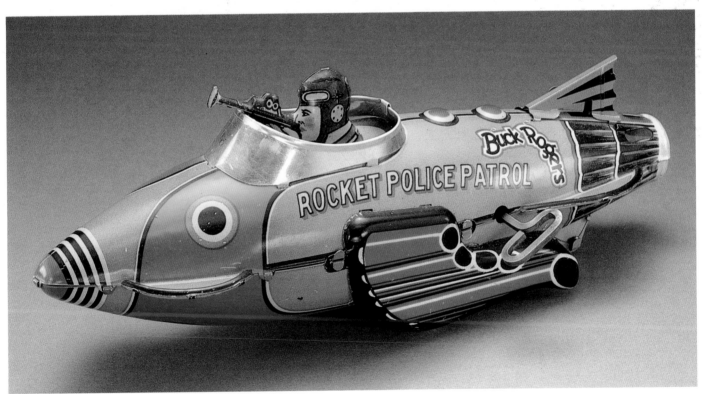

🔵 9×31×12/LOUIS MARX/W/1940'S

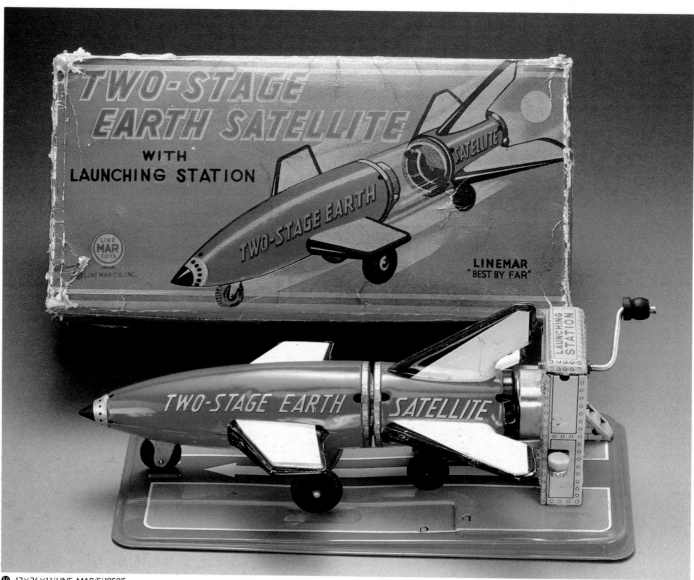

59 12×26×11/LINE MAR/F/1950'S

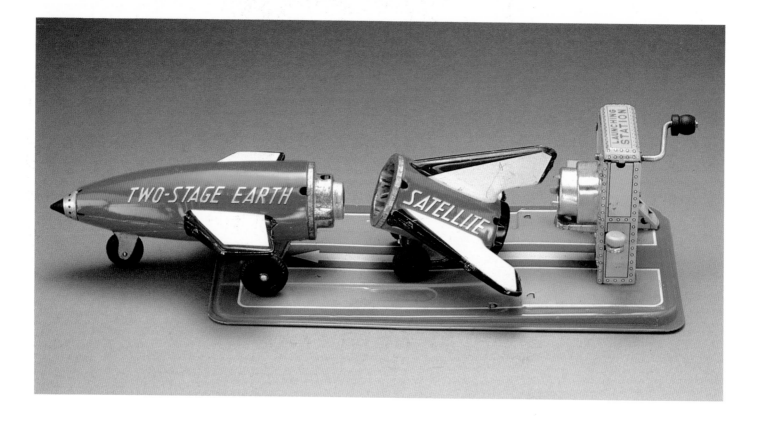

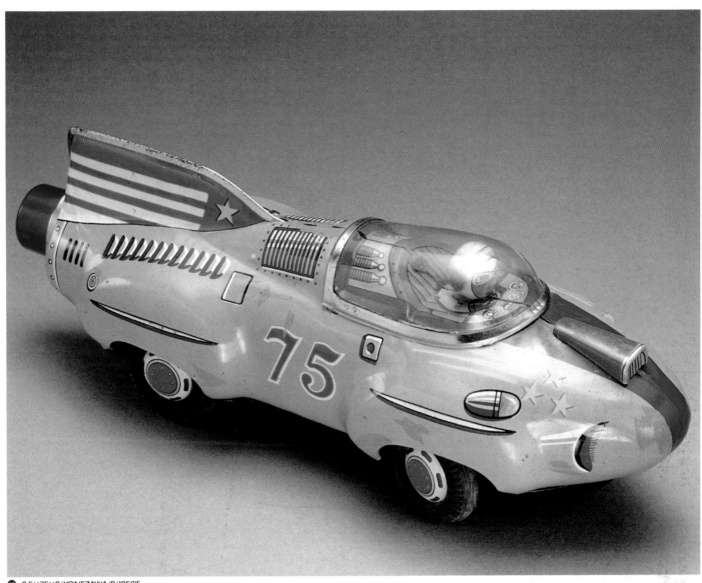

60 8.5×25×9/YONEZAWA/B/1950'S

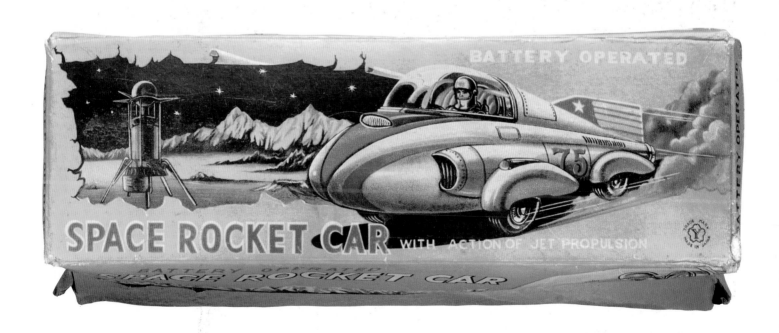

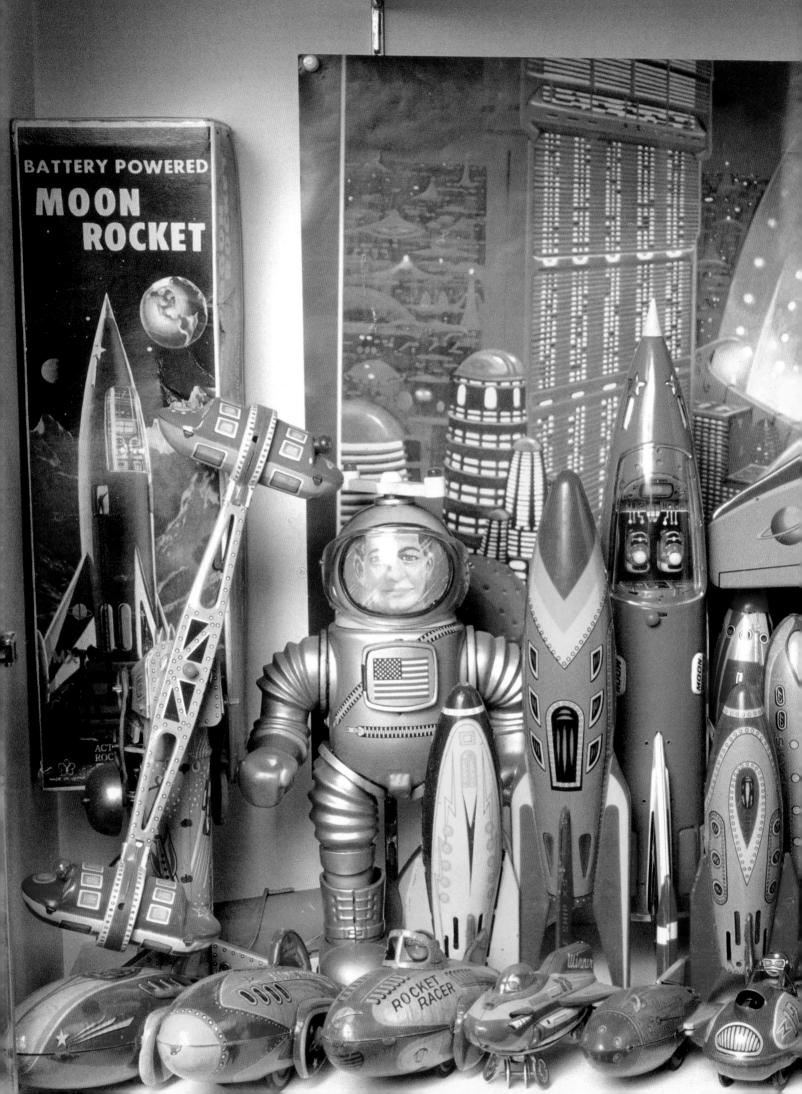

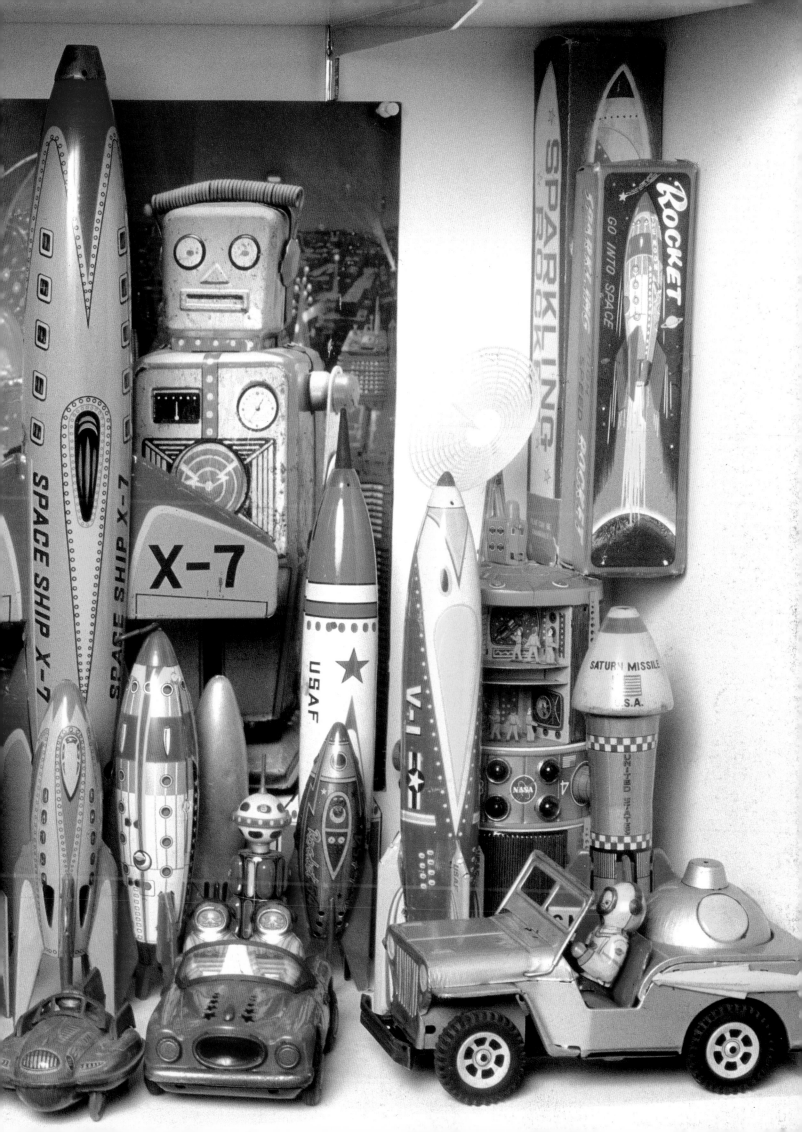

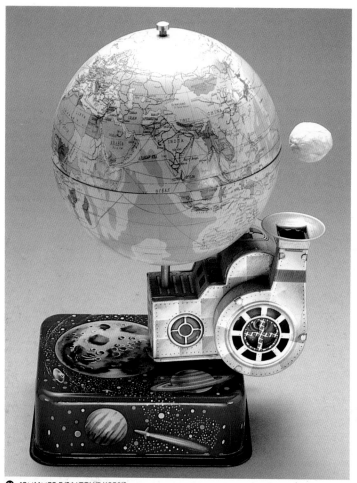

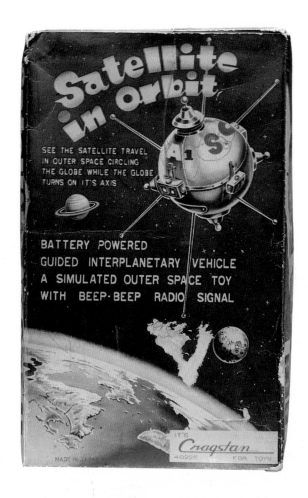

61 13×11×23.5/S.N.TOY/B/1950'S

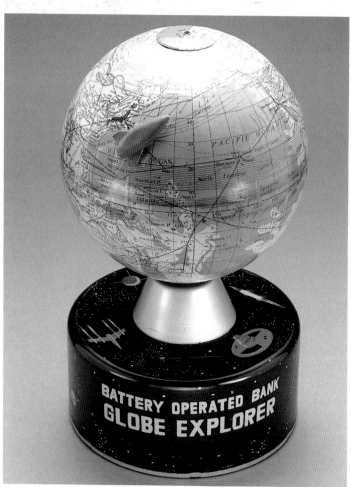

62 13.5×13.5×23/WAKASUTO BOEKI/B/1950'S

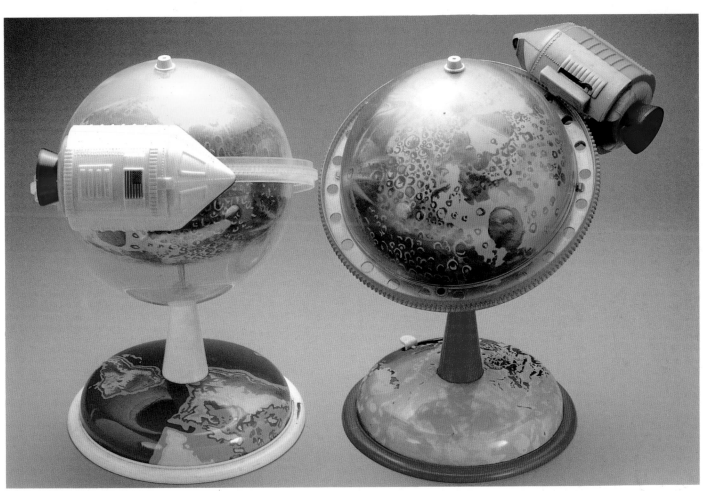

63 64 16×16×26/YONEZAWA/B/1960'S

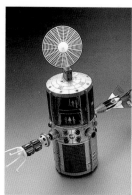

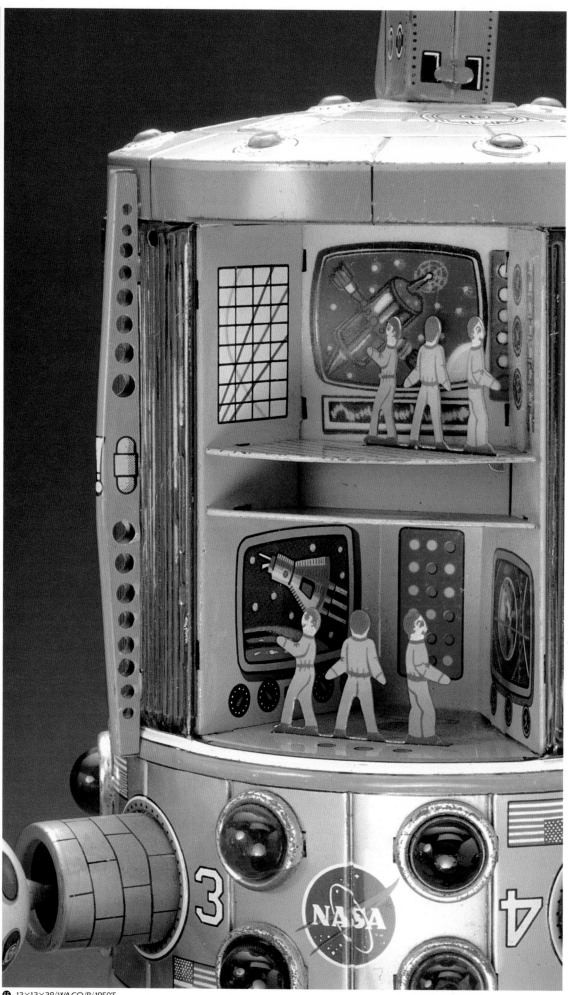

65 13×13×38/WACO/B/1950'S

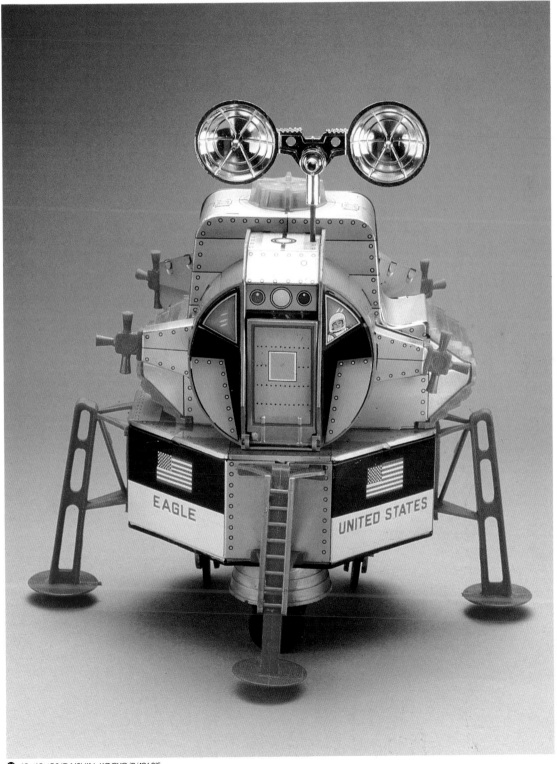

66 18×18×20/DAISHIN KOGYO/B/1960'S

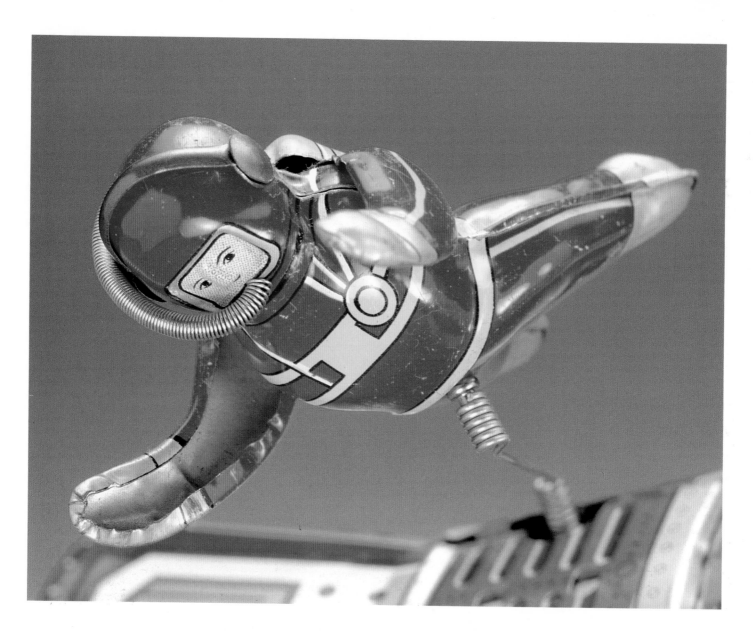

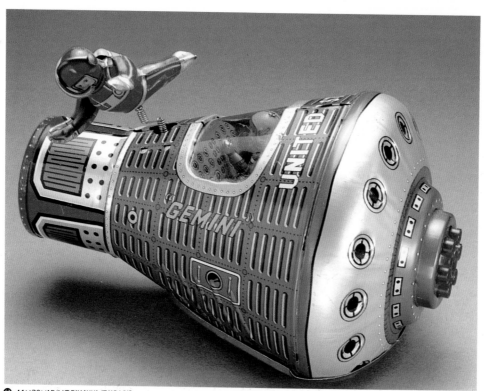

67 14×20×15/HORIKAWA/F/1960'S

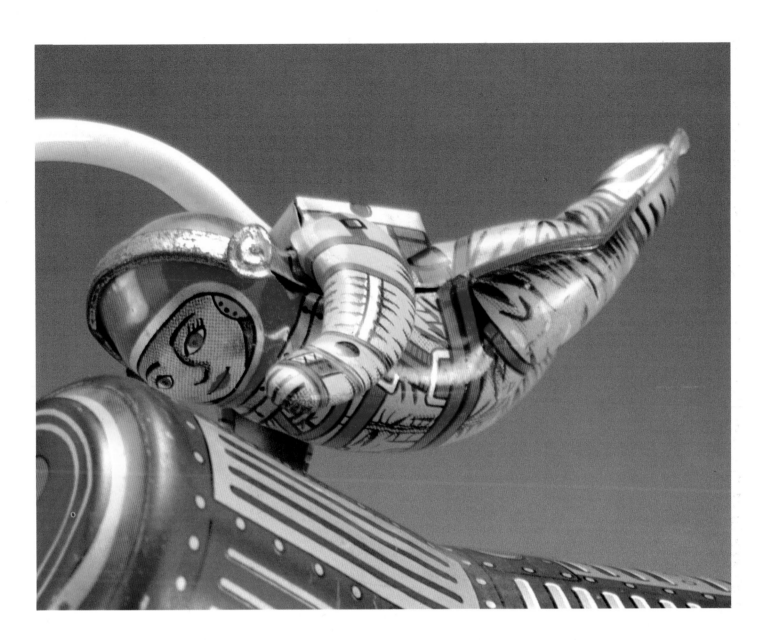

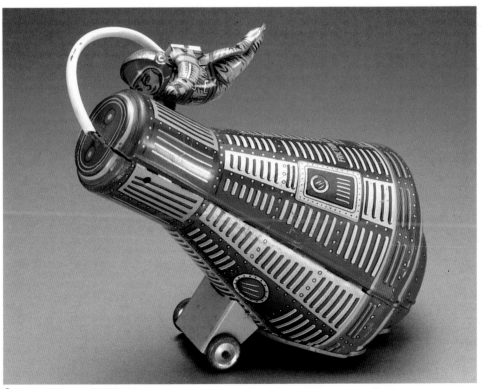

❽ 9.5×16×11/KANTO TOY/F/1960'S

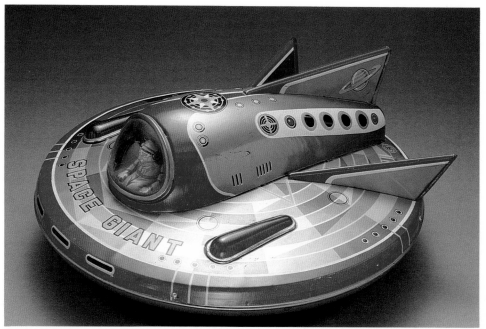

⑲ 31×31×12/MASUDAYA/B/1950'S

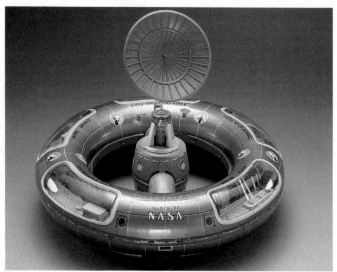

⑳ 30×30×23/HORIKAWA/B/1950'S

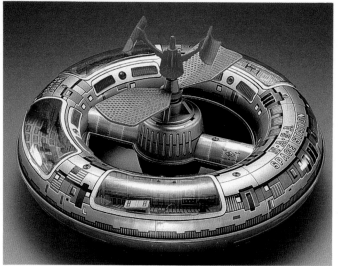

㉑ 29×29×16.5/HORIKAWA/B/1960'S

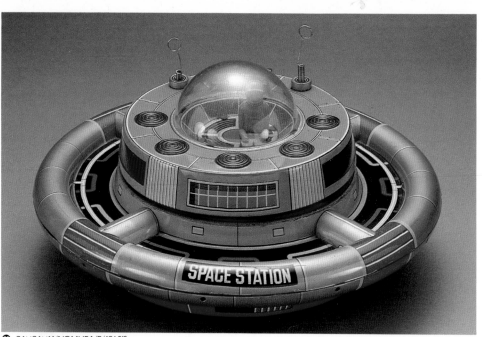

㉒ 24×24×11/NOMURA/B/1960'S

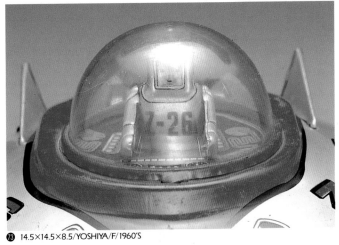

⑳ 14.5×14.5×8.5/YOSHIYA/F/1960'S

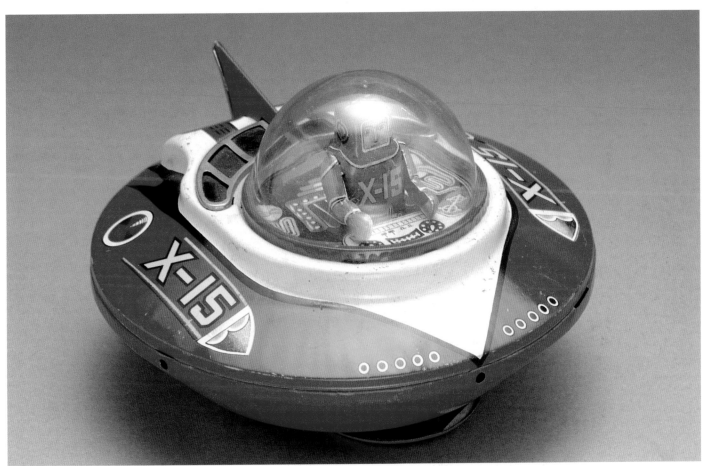

⑳ 14×14×9.5/UNKNOWN/F/1950'S

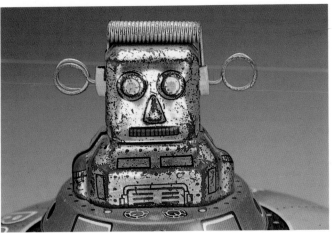

⑳ 13×13×8/ASAHI/F/1950'S

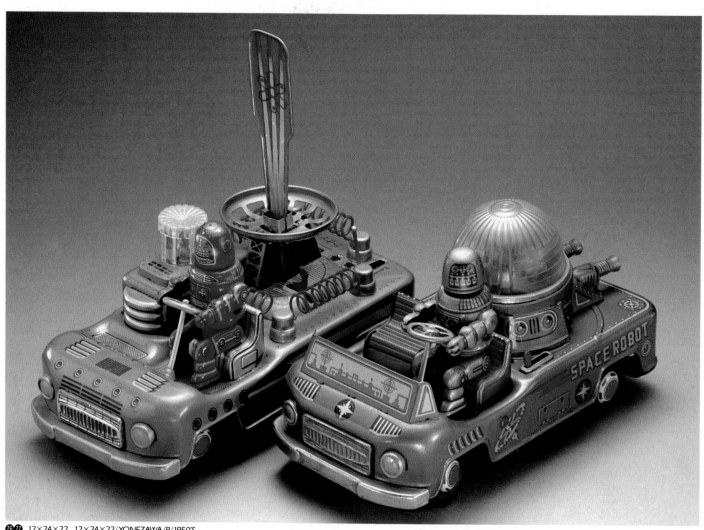

76 77 12×24×22, 12×24×22/YONEZAWA/B/1950'S

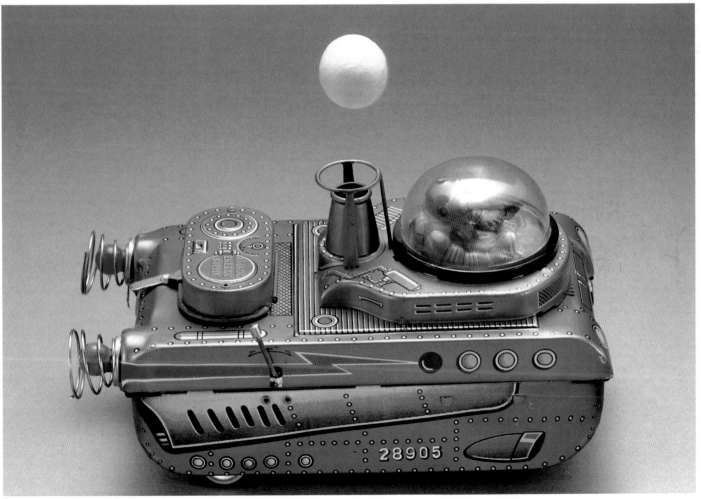

78 10×21.5×11.5/MASUDAYA/B/1950'S

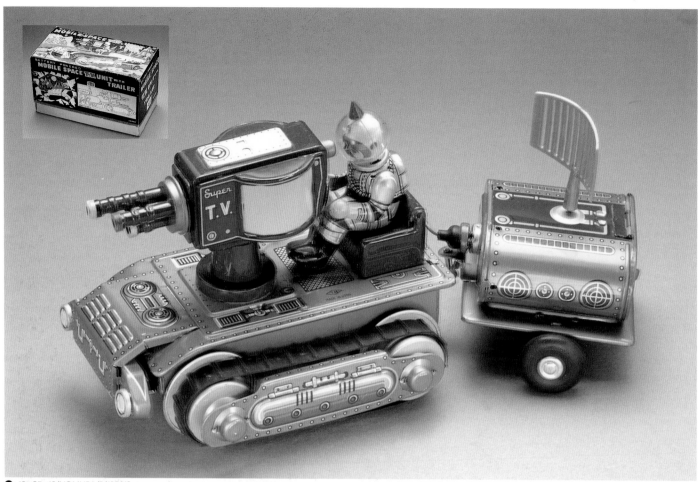

79 12×27×13/NOMURA/B/1950'S

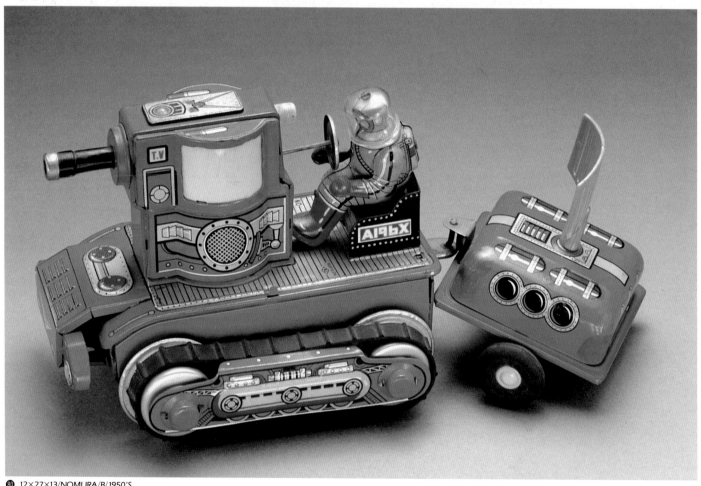

80 12×27×13/NOMURA/B/1950'S

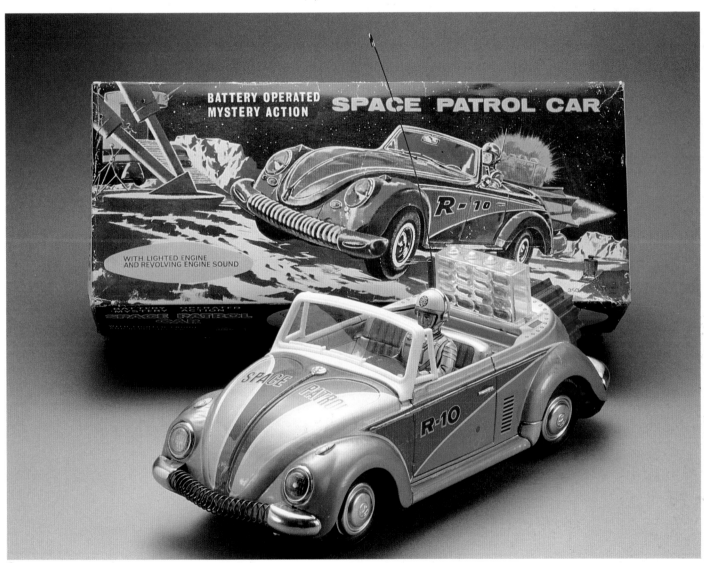

⑧ 13×23×12/NOMURA/B/1960'S

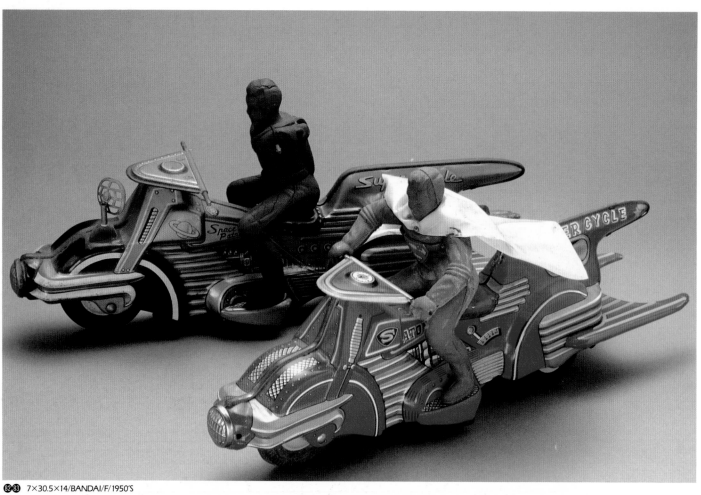

82·83　7×30.5×14/BANDAI/F/1950'S

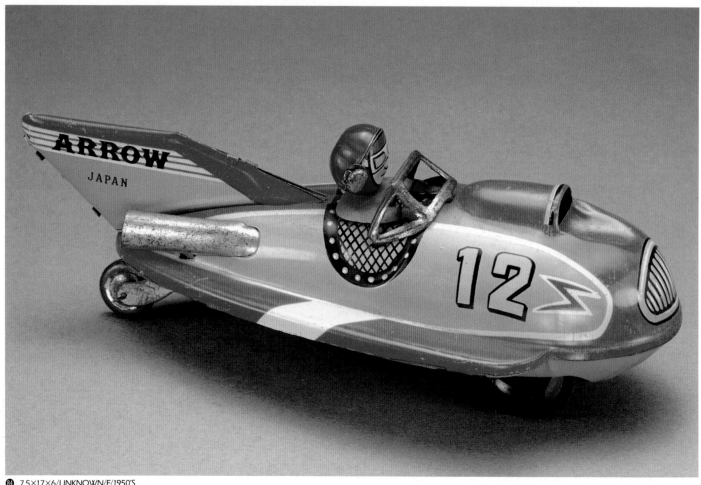

84　7.5×17×6/UNKNOWN/F/1950'S

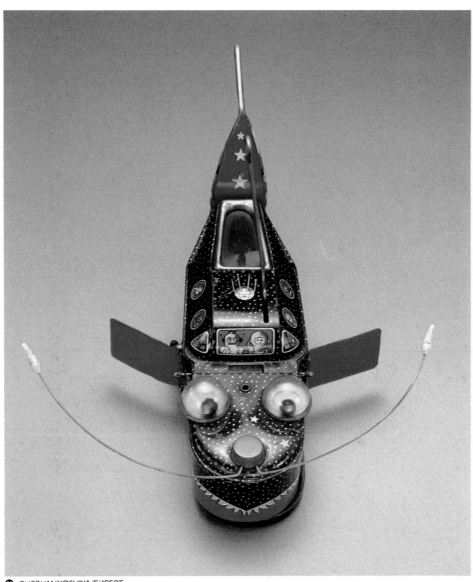

85 7×22×11/YOSHIYA/F/1950'S

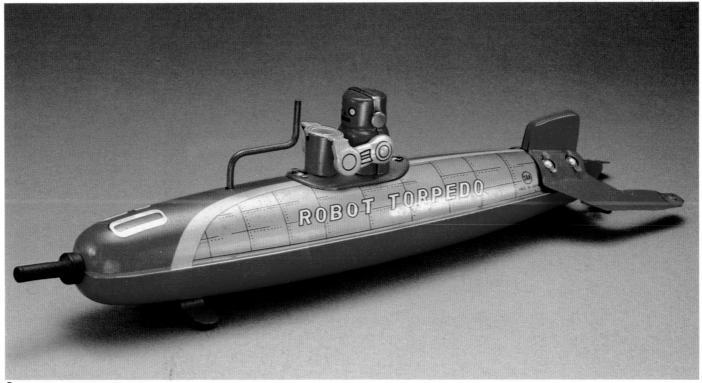

86 6.5×29.5×7.5/MARUSAN/F/1950'S

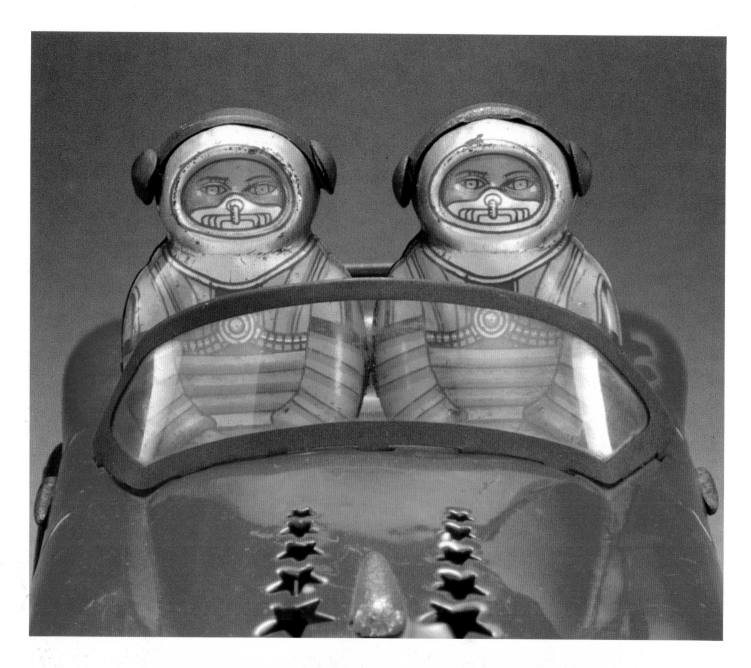

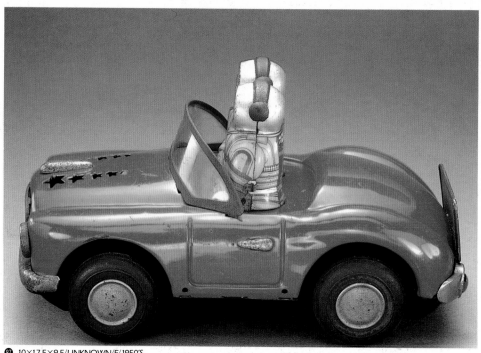

⑧⑦ 10×17.5×9.5/UNKNOWN/F/1950'S

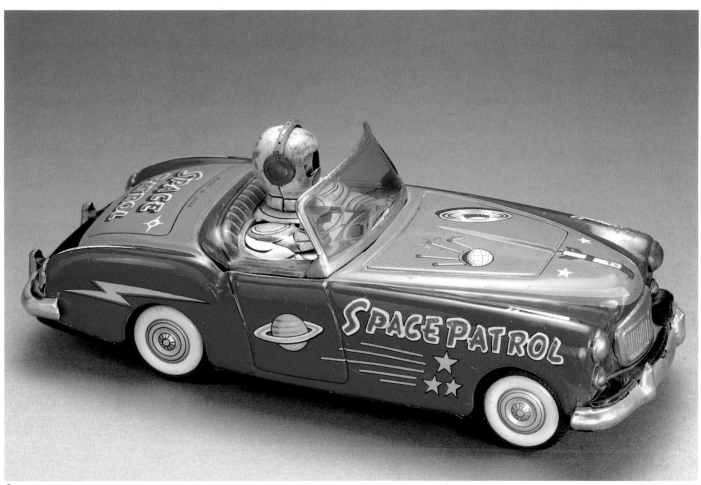

88 8×21×8/UNKNOWN/F/1950'S

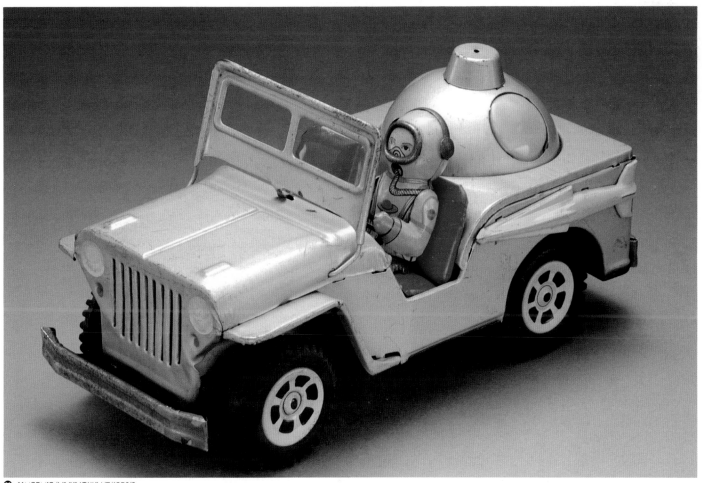

89 11×25×12/UNKNOWN/F/1950'S

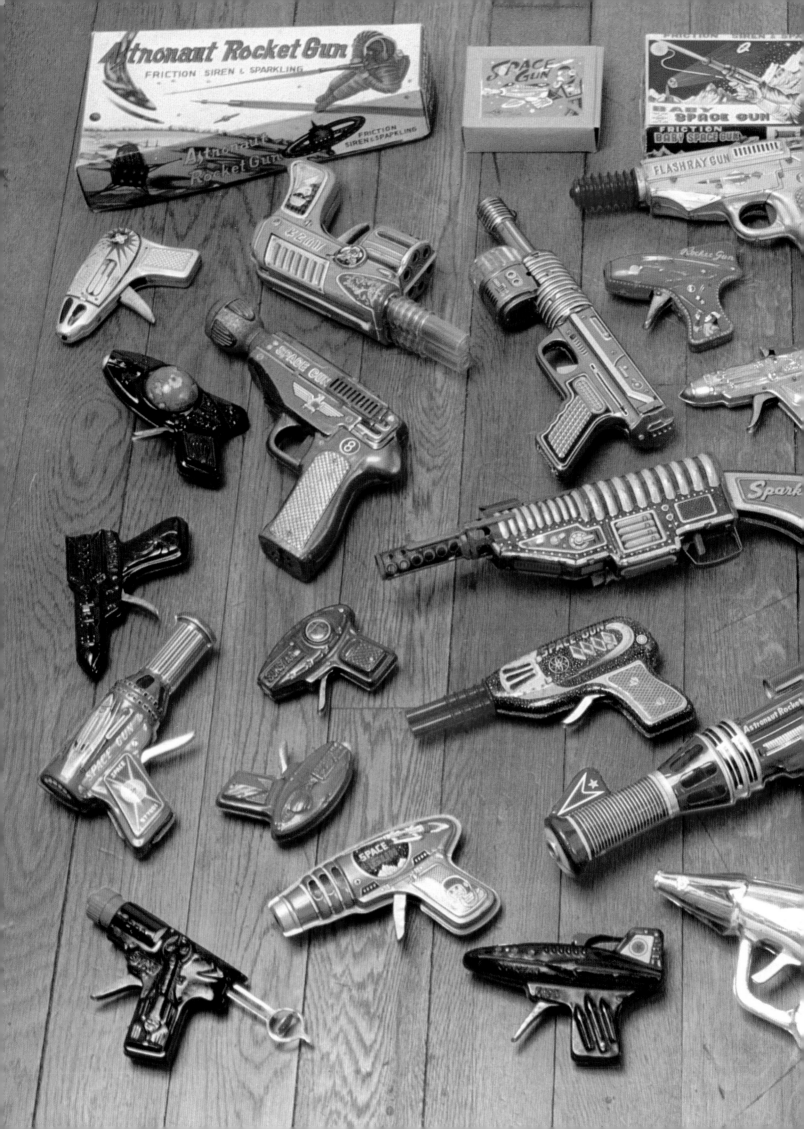

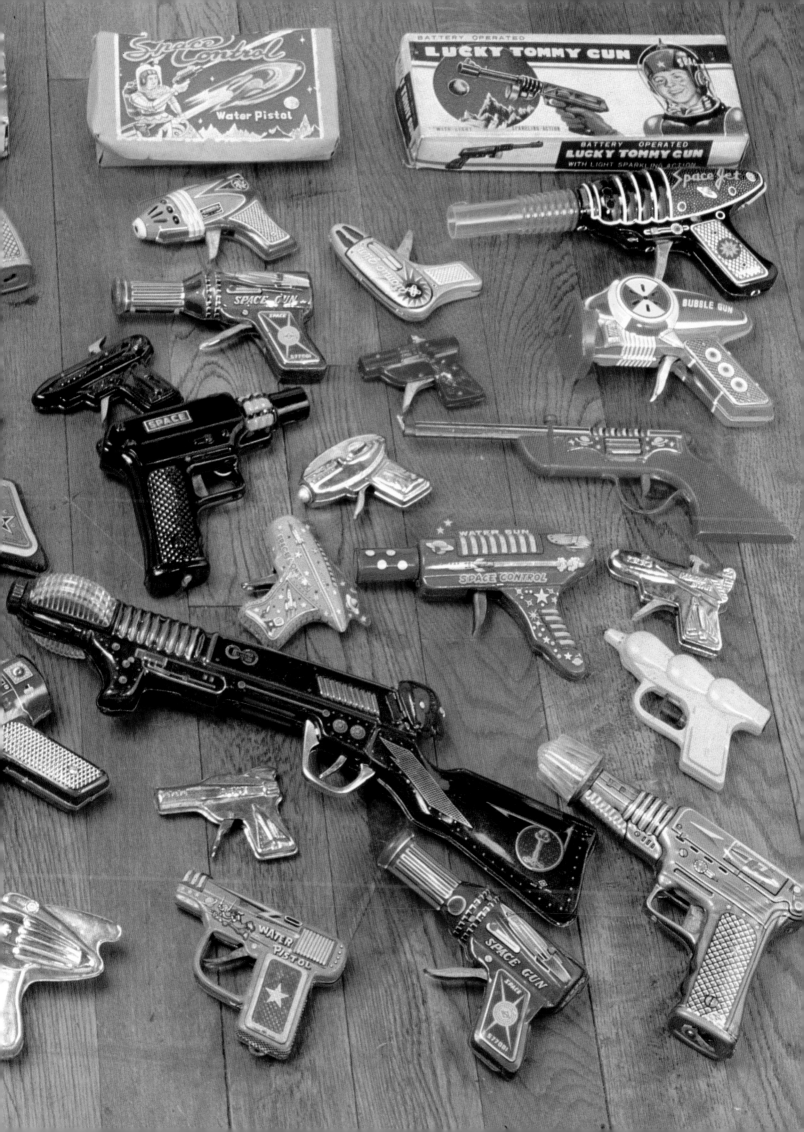

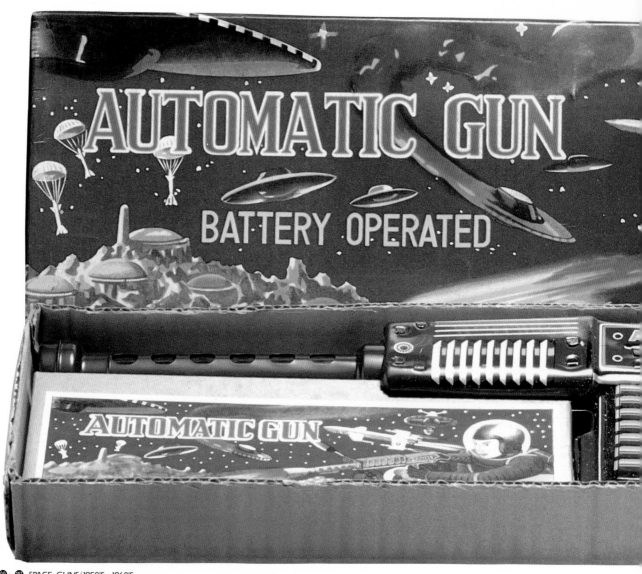

90~107 SPACE GUNS/1950'S~1960'S

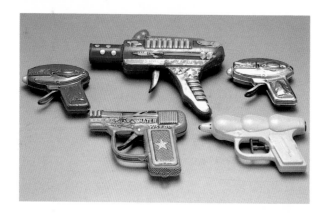

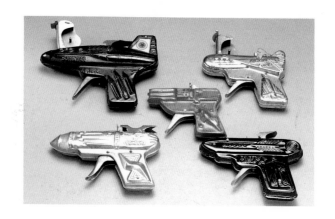

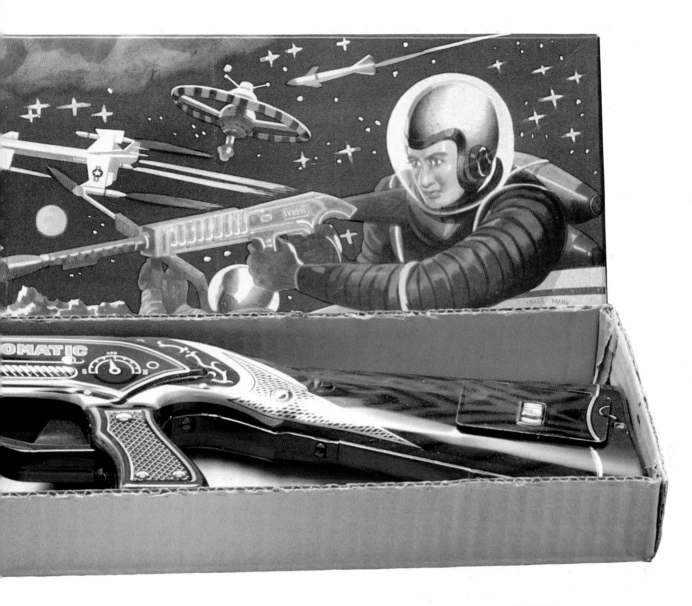

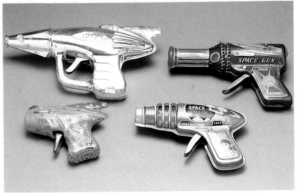

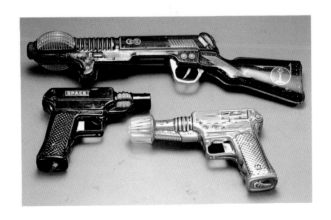

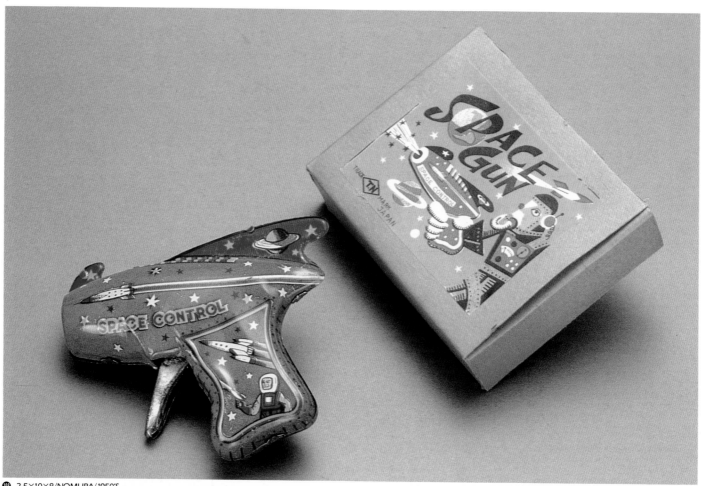

⑩ 2.5×10×8/NOMURA/1950'S

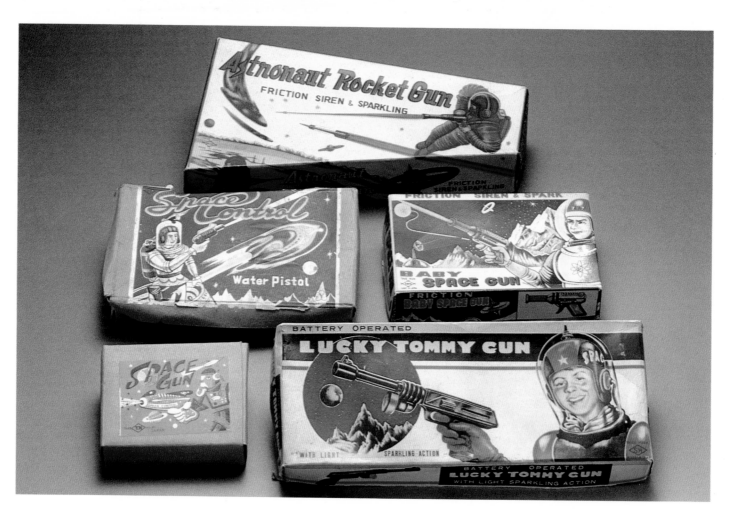

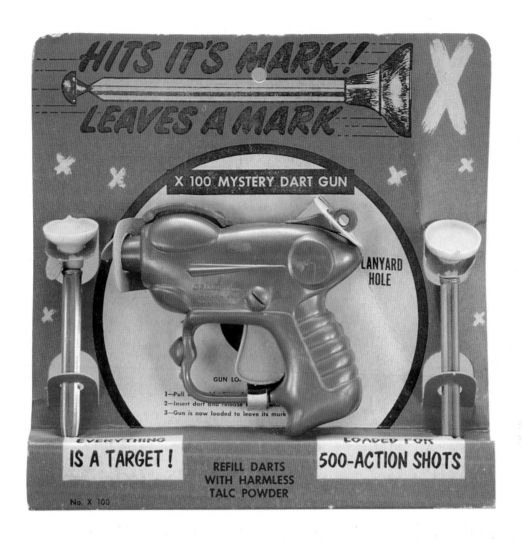

HITS IT'S MARK!

LEAVES A MARK

X 100 MYSTERY DART GUN

LANYARD HOLE

GUN LO...

1—Pull ...
2—Insert dart and release ...
3—Gun is now loaded to leave its mark

IS A TARGET !

EVERYTHING

REFILL DARTS
WITH HARMLESS
TALC POWDER

LOADED FOR

500-ACTION SHOTS

No. X 100

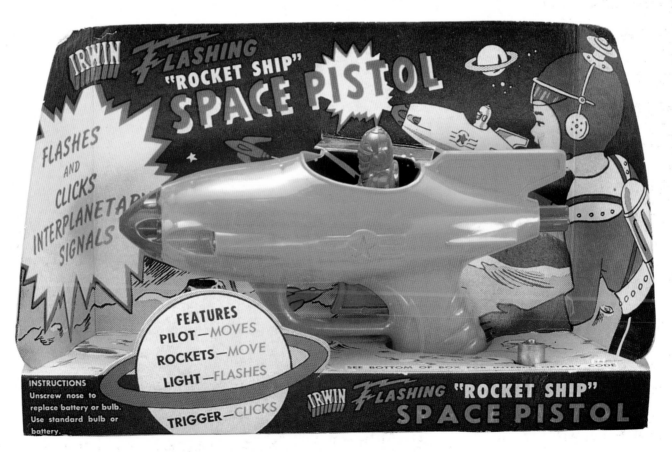

IRWIN *Flashing* "ROCKET SHIP" **SPACE PISTOL**

FLASHES
AND
CLICKS
INTERPLANETARY
SIGNALS

FEATURES
PILOT—MOVES
ROCKETS—MOVE
LIGHT—FLASHES
TRIGGER—CLICKS

INSTRUCTIONS
Unscrew nose to
replace battery or bulb.
Use standard bulb or
battery.

SEE BOTTOM OF BOX FOR INTERPLANETARY CODE

IRWIN *Flashing* "ROCKET SHIP"
SPACE PISTOL

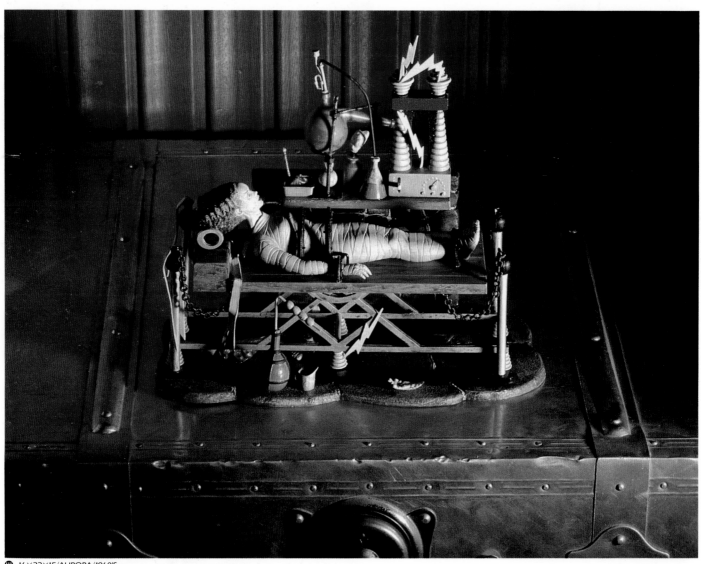

⓫ 16×22×15/AURORA/1960'S

⑫ 8×20×25/AURORA/1960'S

⑬ 20×13×23/AURORA/1960'S

⑭ 13.5×9.5×21/AURORA/1960'S

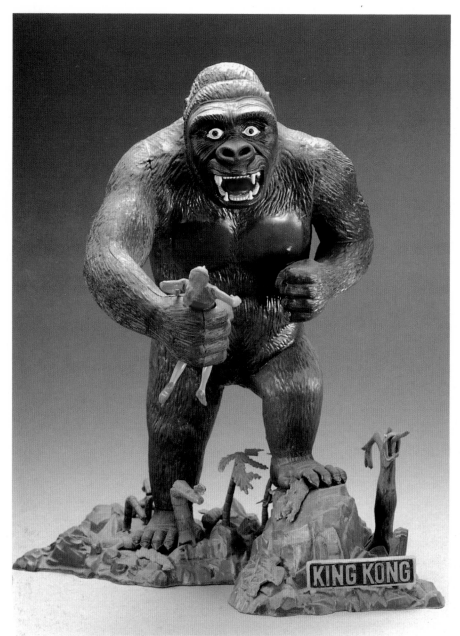

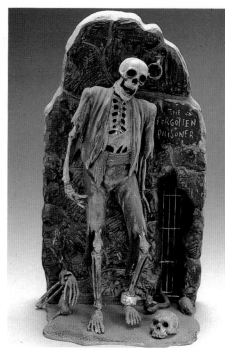

⑯ 11×8.5×22/AURQRA/1960'S

⑮ 22×13×24/AURORA/1960'S

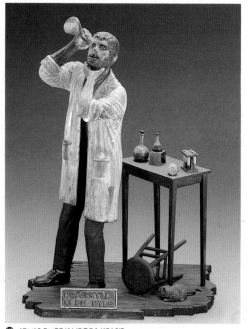

⑰ 15×10.5×22/AURORA/1960'S

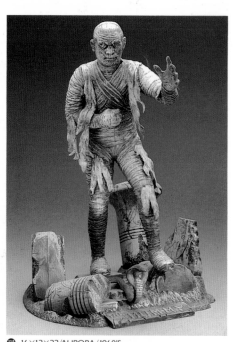

⑱ 16×12×22/AURORA/1960'S

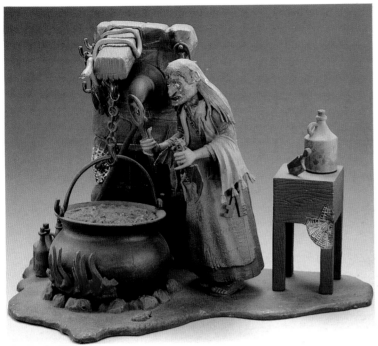

⑲ 21×14×15/AURORA/1960'S

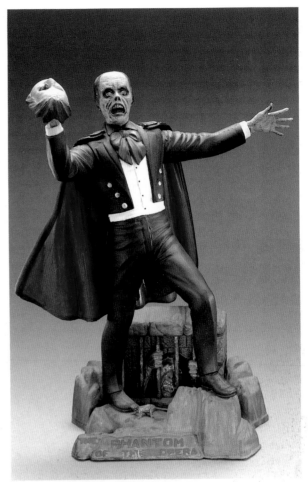

⑳ 13.5×9.5×23.5/AURORA/1960'S

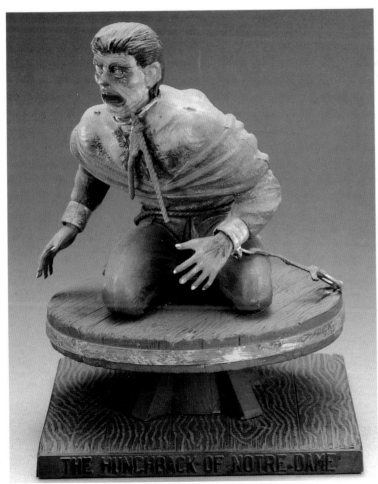

㉑ 12.5×12.5×16/AURORA/1960'S

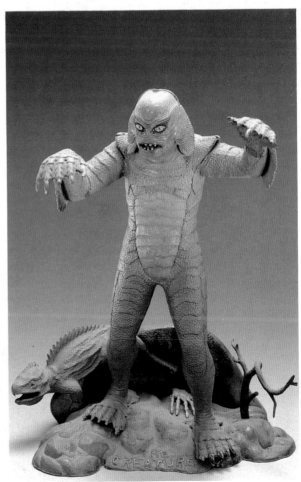

㉒ 16×14×21/AURORA/1960'S

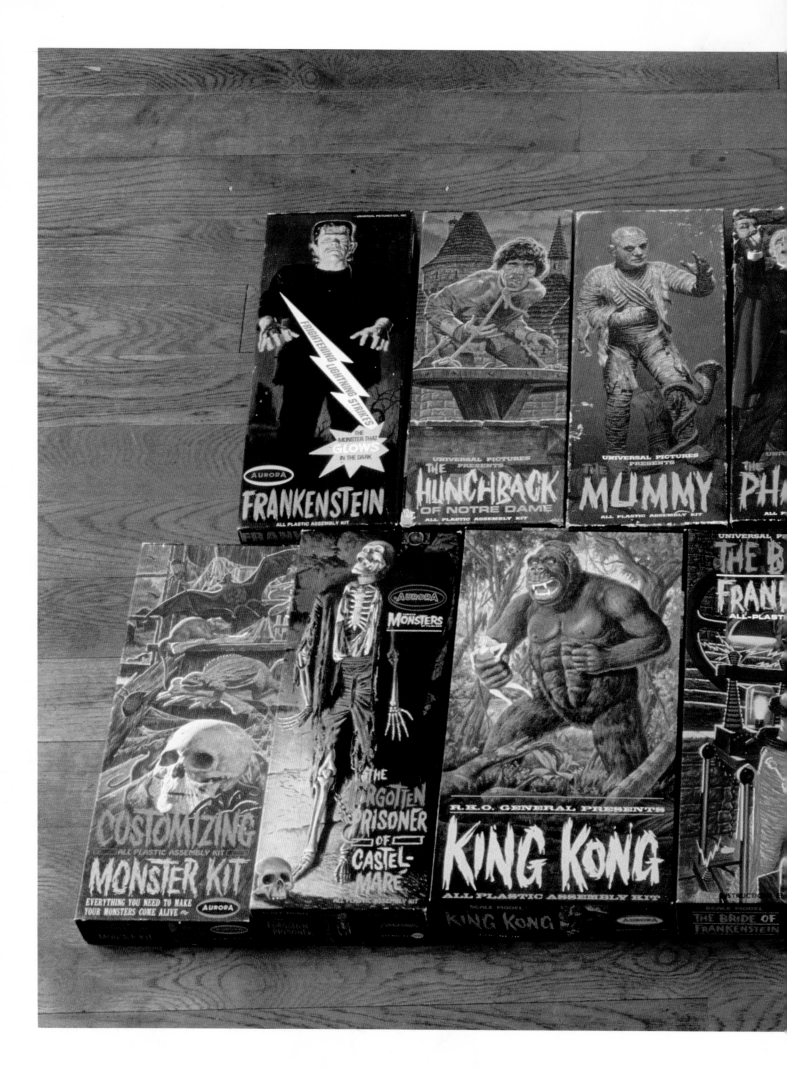

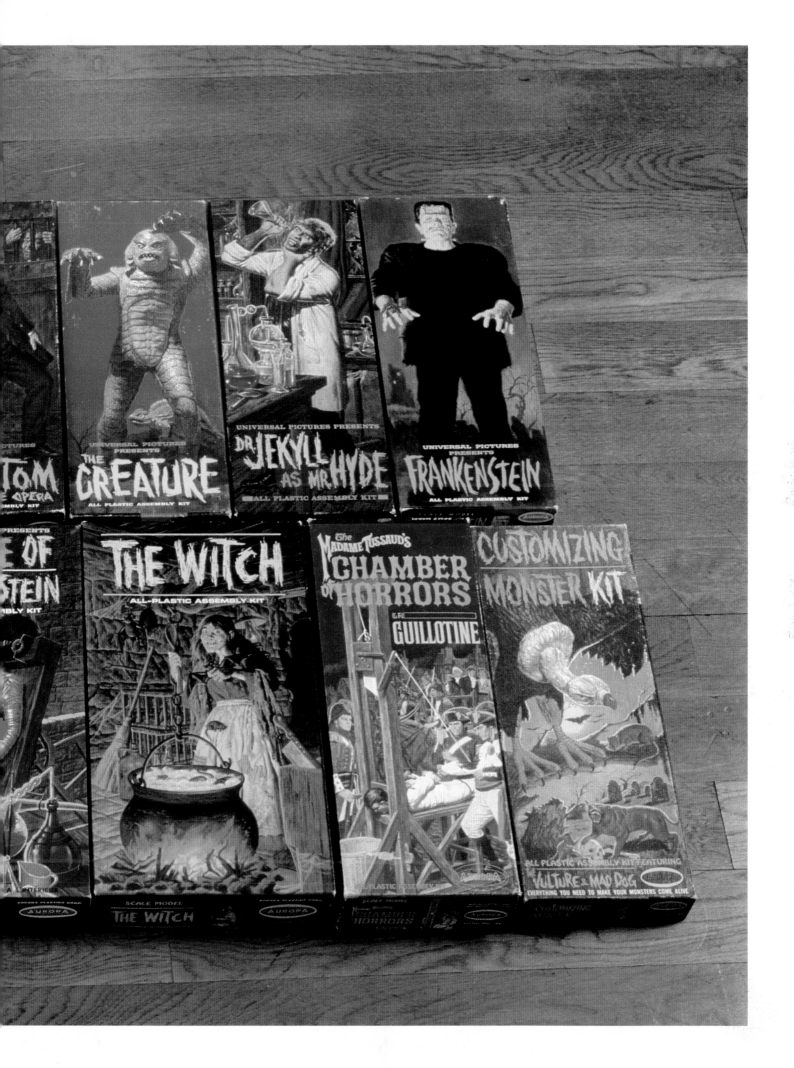

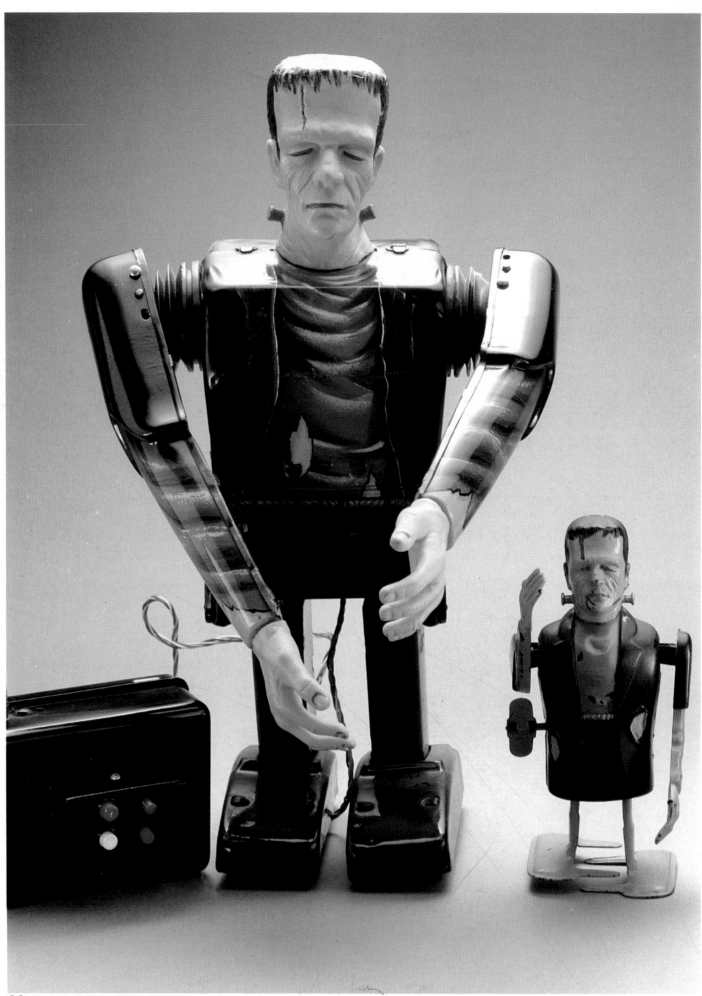

123 124 19×12×32, 7×5.5×14/MARX/B, W/1950'S

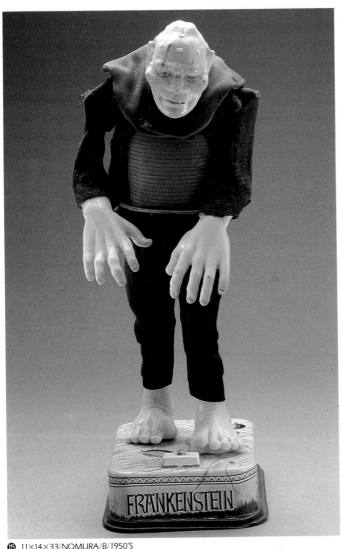

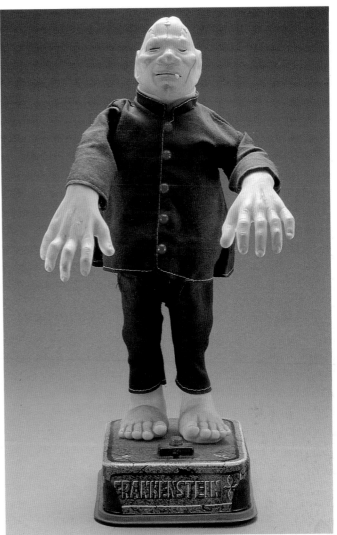

125 11×14×33/NOMURA/B/1950'S

126 11×14×33/NOMURA/B/1960'S

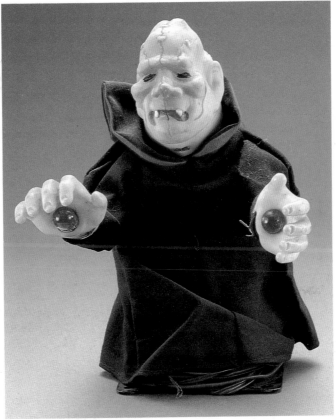

127 8×7×17/UNKNOWN/B/1950'S

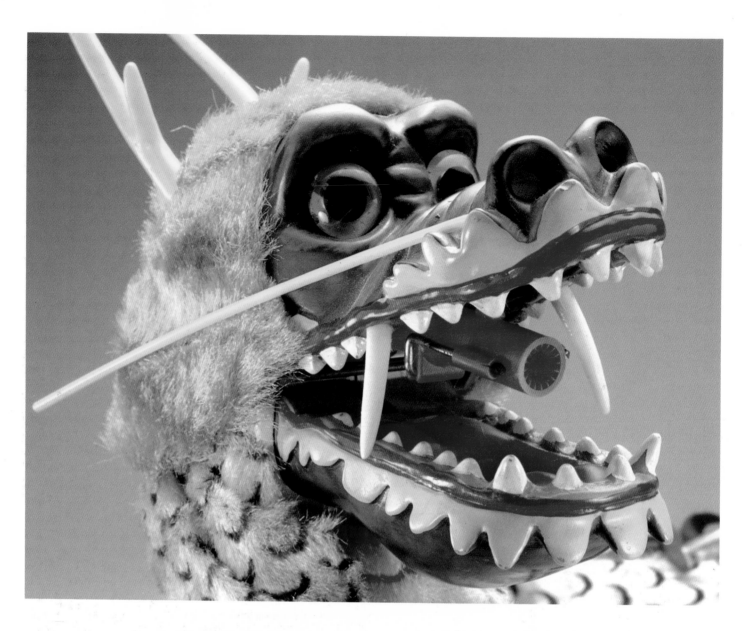

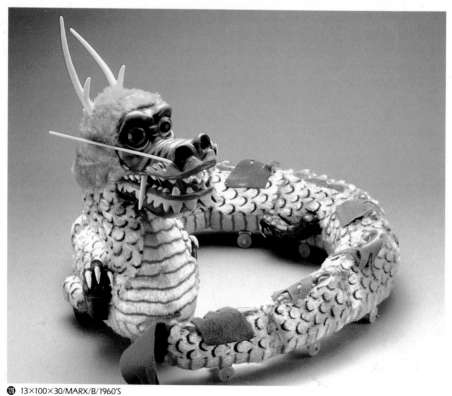

⑰ 13×100×30/MARX/B/1960'S

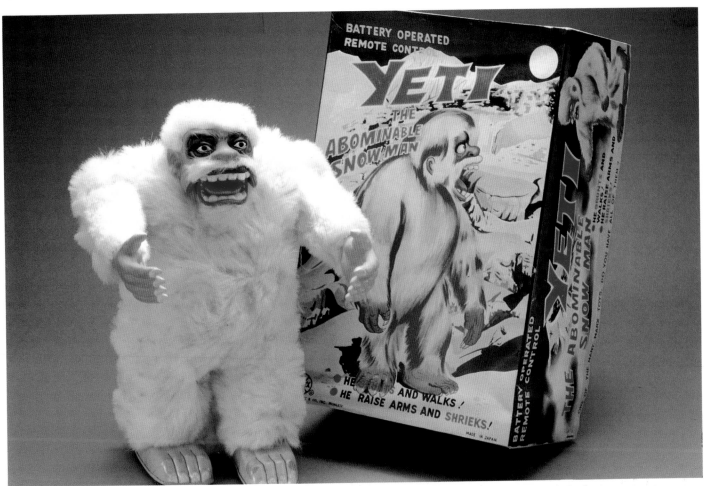

129 18×10×28/MARX/B/1950'S

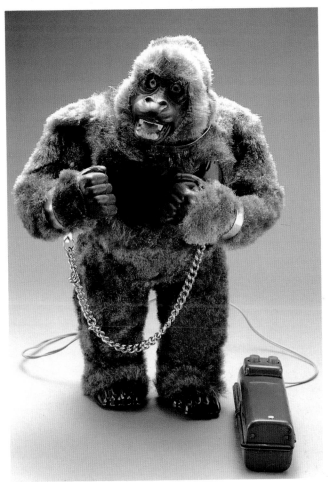

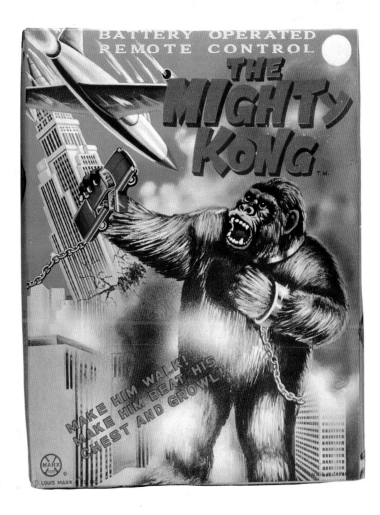

130 21×12×27/MARX/B/1950'S

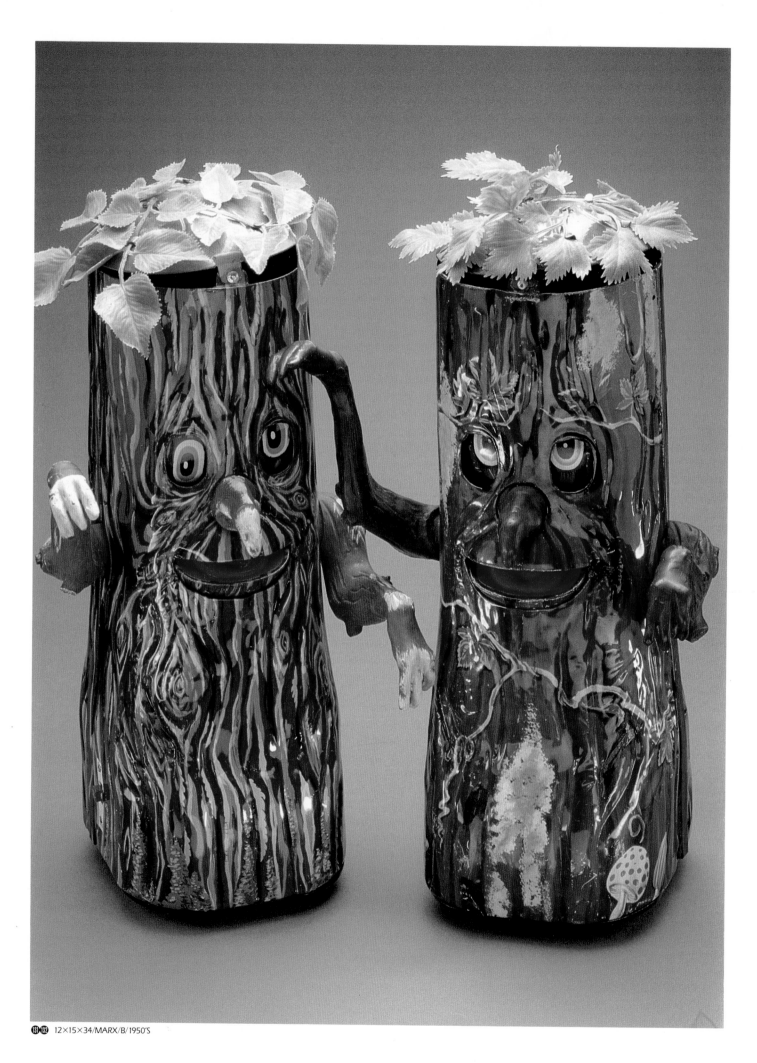

131·132 12×15×34/MARX/B/1950'S

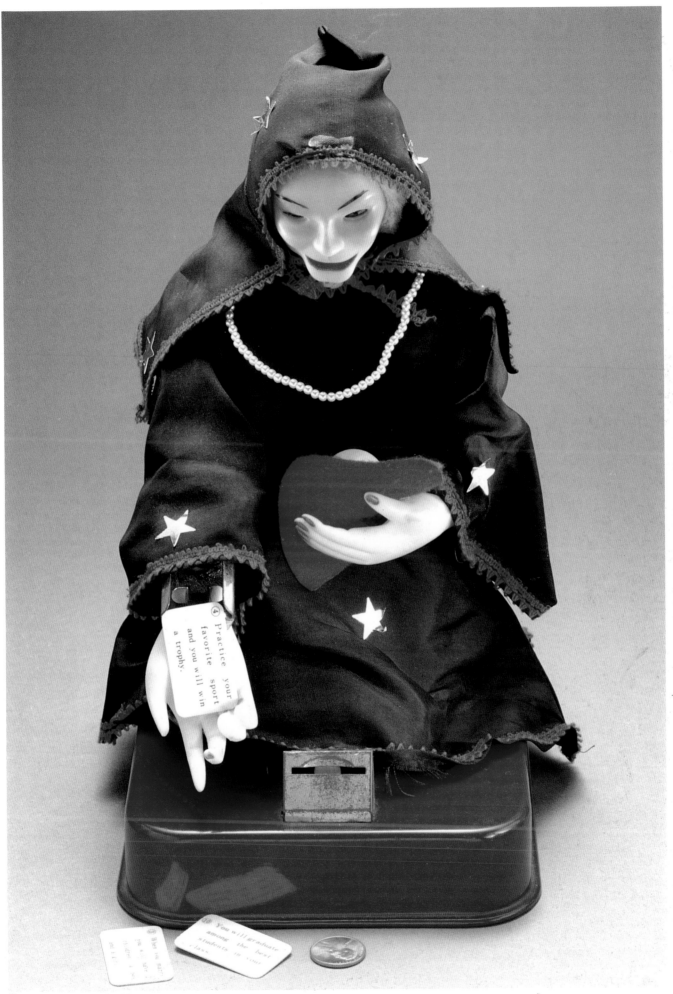

138 16×17.5×27/ICHIDA/B/1950'S

136 137 6.5×6.5×2, 3×9×1/UNKNOWN/1950'S

184 185 2×2×5.5, 4×4×16/UNKNOWN/1950'S

188 8×16.5×9/MASUDAYA/F/1950'S

189 2.5×14×2.5/UNKNOWN/1950'S

⓵⓵ 16×2×12, 22×27/UNKNOWN, MITSUWA/1950'S

⓵ 17×4.5×14/SHOYA/1950'S

143 1950'S

144 1950'S

145 1950'S

146 1950'S

147 1950'S

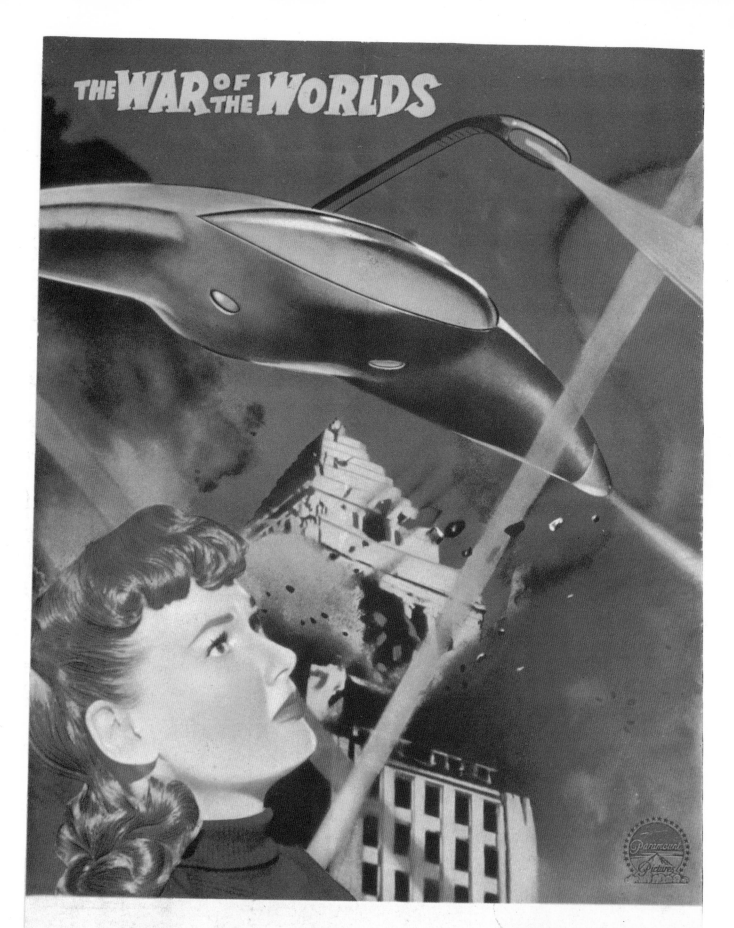

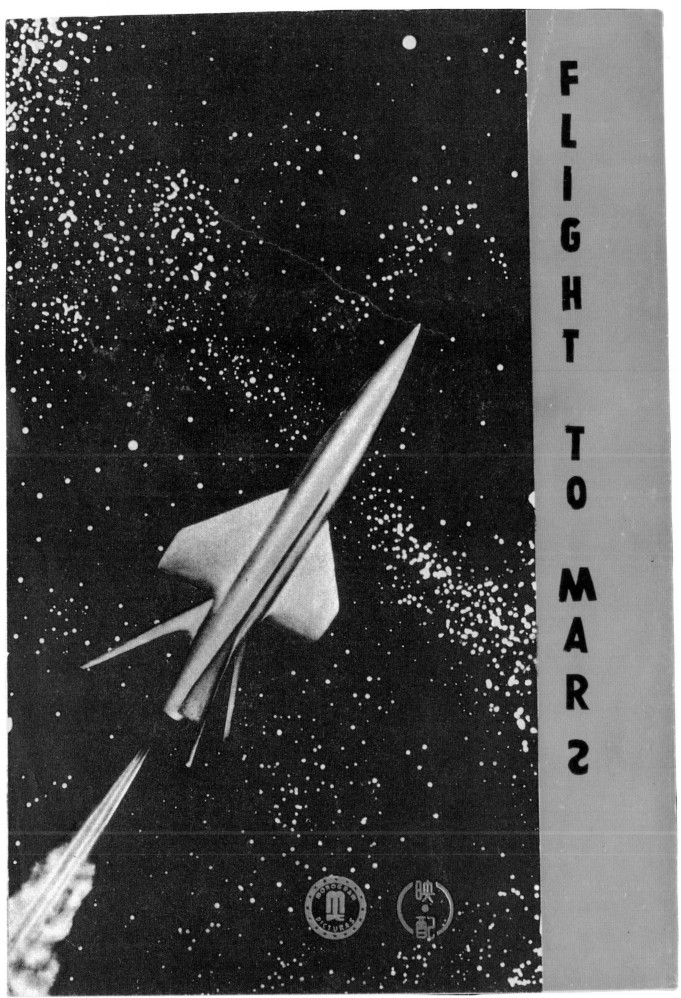

FLIGHT TO MARS

150 1950'S

151 1950'S

152 1950'S

153 1950'S

154 1950'S

155 1950'S

156 1950'S

157 1950'S

150 1940'S

159 1930'S

EXPLANATION

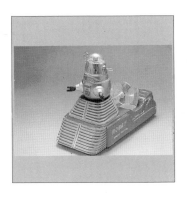

Figure 5 (battery operated): This is "Robby," which first appeared in the 1956 film *The Forbidden Planet*. In Figure 5, Robby appears in combination with a space patrol car. He can be seen on his own in Figure 6.

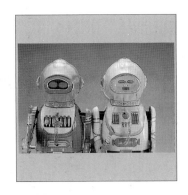

Figures 15 and 16 (wind-up): This robot was produced in the 1950s. The coiled wire pipe leading from its head to the tank on its back gives it a futuristic, sci-fi feeling. The expression on this robot's face is very interesting.

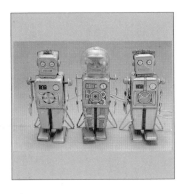

Figure 6 (battery operated): When batteries are inserted into its legs, this robot walks and the piston on its head goes up and down. After this Robby robot appeared, many robots were made with the same trademark transparent head.

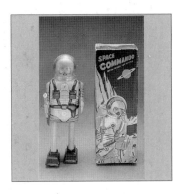

Figure 17 (battery operated): It is very unusual for a robot to play a musical instrument; at best, a robot can only manage a drum. This robot's hands move up and down to strike the drum and at the same its feet march and its eyes light up.

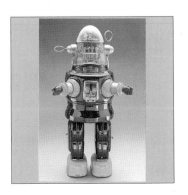

Figure 11 (battery operated): The sci-fi transparent helmet is the most distinctive feature of this toy. This 1950s, battery-operated robot is extremely rare. Figures 10, 11, and 12 are variations on the same toy.

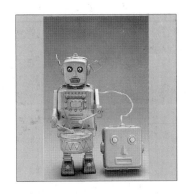

Figure 18 (wind-up): Dressed as an astronaut, this robot carries a space can on his hips. Robots without helmets on their heads are quite common, but this one, with his head encapsulated in a transparent dome, is unique. Both hands and feet are movable.

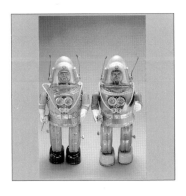

Figures 13 and 14 (battery operated): The hands and feet of these robots move when batteries are inserted into their feet. Each robot holds a transceiver and wears a panel of red lights that turn on and off. These light switches also operate lights that illuminate the faces of the robots.

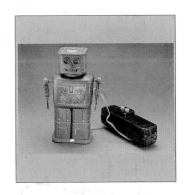

Figure 19 (battery operated): This robot's eyes light up, and pins can be extended from its feet to enable it to walk. This kind of robot with walking pins was very common in the 1950s, but is now very rare.

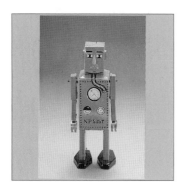

Figure 20 (wind-up): This robot was constructed in the 1940s and is the oldest example of its kind. Its boxy head and body give it a primitive, simplistic look.

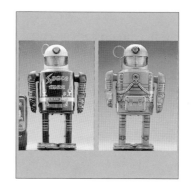

Figures 25 and 26 (battery operated): This robot has a variety of functions— it moves both forward and backward, its head lights up, and its hands move. Batteries for Figure 26 (right) are inserted into the tank on its back, and this weight is countered by lead on its front. Its antenna serves as its on-and-off switch.

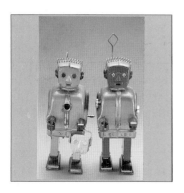

Figures 21 and 22 (Figure 21, wind-up, and Figure 22, battery operated): Apart from their difference in mechanism, these robots are quite similar. The clamp-style hands indicate that these are powerful robots, able to grip as well as walk.

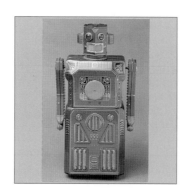

Figure 27 (battery operated): This robot has no feet. When the circle on its chest touches a rubber suction disk beneath it, the wheels below go into action. A light inside its mouth illuminates its head, and its bulky monumentality gives an impression of power.

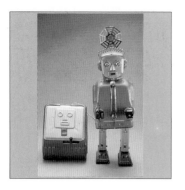

Figure 23 (battery operated): Embellished with a parabola antenna on its head and eyes that light up, this amusing robot was apparently a best-seller, as it went through a variety of new packages in its considerable lifetime.

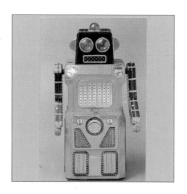

Figure 28 (battery operated): Another footless robot, this example has lights in its eyes, head, and mouth and a siren that goes off. Like Figure 27, its monolithic shape makes it seem quite powerful.

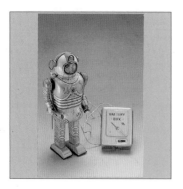

Figure 24 (battery operated): Combining the costume of an astronaut with the perambulation and lighting effects of a robot, this futuristic toy was produced around the time that Yuri Gagarin was the first man in space.

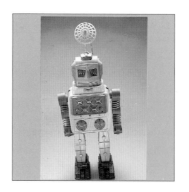

Figure 29 (battery operated): Inserting an antenna operates this robot's switch. The robot fires missiles from its chest every five or six steps. The missiles are suprisingly large.

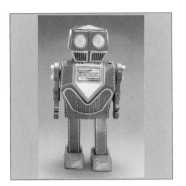

Figure 32 (battery operated): After taking a few steps, the face of this robot splits open to reveal the face of an angel. The head then joins itself together and it continues walking, only to repeat the performance again a few steps later with the face of a devil. This is a very peculiar robot.

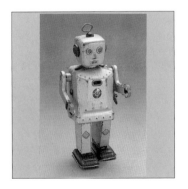

Figure 33 (wind-up): This odd-looking robot has wrenches for hands and can walk forward while his arms remain stationary. Figure 36 has the same body with a different head.

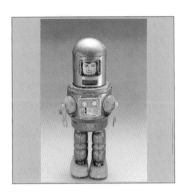

Figure 34 (wind-up): This example is the most robot-like of all. It is so typical that it is difficult to enumerate its distinctive features.

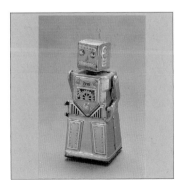

Figure 35 (friction operated): This friction robot is operated with the use of a crank. A push will send it moving forward, waving its head from side to side.

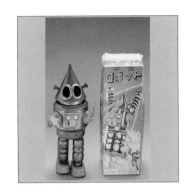

Figure 36 (wind-up): This robot is simply a variant of Figure 33, but it's obvious from the package that it was based on a children's television program called "The Jet Boy." Sparks are emitted from its eyes by means of a flint.

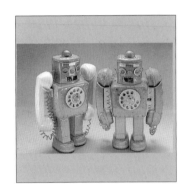

Figures 37 and 38 (wind-up): These strange robots were designed with a telephone theme—their arms are telephone receivers and dials appear on their chests. The receivers have been made from two different materials: tinplate and plastic.

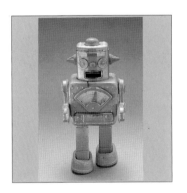

Figure 39 (wind-up): Similar in shape to Figures 37 and 38, this robot has abandoned the telephone motif for a variety of other features, including an oxygen meter and hologramic eyes that seem to wink when seen from an angle.

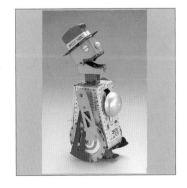

Figure 40 (wind-up): This example is half-human and half-robot. The design has been strongly influenced by the television program "Robot Santohei (the third private)," which was popular when it was made. It opens and closes its mouth continually while its bell rings.

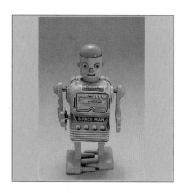

Figure 41 (wind-up): This robot has a cute face and distinctive feet that resemble an ice-shaving machine. The new-look plastic legs contrast with the old-style body.

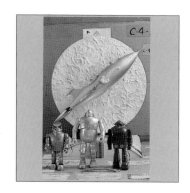

Figures 47 through 49 (battery operated): These robots flash their eyes while walking. All the parts are exceedingly well expressed considering that they are made of plastic.

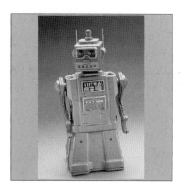

Figure 42 (battery operated): When it bumps into a wall or other object, this robot turns around and advances away from the obstruction. Its head can be removed to replace the lightbulb that illuminates its eyes.

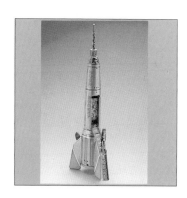

Figure 50 (friction operated): When the point of this horizontal rocket comes into contact with any form of obstruction, a lever is operated, and it jerks up to a vertical position. Two flights of steps can be attached to allow easy entry for the astronauts.

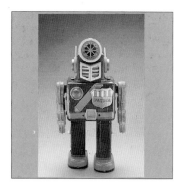

Figure 43 (battery operated): This novelty robot blows smoke out of its mouth and has a siren on its head.

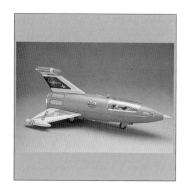

Figure 51 (battery operated): This is the 1950s idea of what the space shuttle of the future would look like. The cockpit lights up, and various devices, such as an antenna, can be attached. The lightbulb can easily be changed by opening the compartment near the front wheel.

Figures 44 through 46 (battery operated): Every few steps, these robots will stop, flash their eyes on and off, and then blow smoke out of their mouths. The smoke is produced by a wire inside being heated and reacting against some oil-soaked cotton wool. The smoke is then blown out of the head by a bellows.

Figure 52 (friction operated): This is an unusually large rocket for its type (26″ x 56″ x 11″). Such a huge toy must have been a delight for small children.

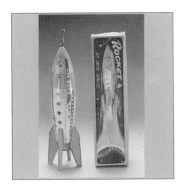

Figure 53: This uncommon rocket is hung by a string. The nose of the rocket is hooked onto something high, and then the body is pulled downward. When it is released, the rocket will rewind itself on the string and make sounds like a blast-off.

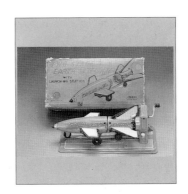

Figure 59 (friction operated): Friction for this rocket is generated by winding the crank and then releasing the rocket. One of its interesting features is that halfway through its journey, it jettisons its booster rockets. Although it was designed for ground use, it creates a perfect outer-space atmosphere.

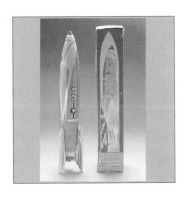

Figure 54 and 55 (friction operated): This 1950s toy only moves forward on its wheels. Its mechanical simplicity has been counterbalanced by its colorful design and interesting shape.

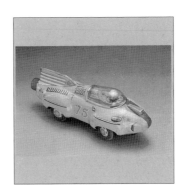

Figure 60 (battery operated): This simple rocket was created in the 1950s; although it only moves forward and lights up, its body pattern is beautiful. Its package gives it an extra sci-fi touch.

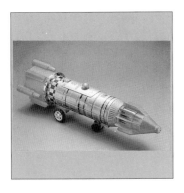

Figure 56 (battery operated): The front and back ends of this rocket light up. The lid of the cockpit opens to reveal the pilot.

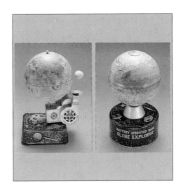

Figure 61 and 62 (battery operated): The globe of Figure 61 rotates while the satellite rises on a cushion of air. The effect is that of a satellite orbiting the earth. Figure 62 is a bank; the rocket orbits the earth every time a coin is inserted.

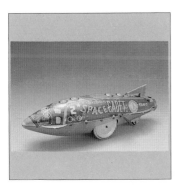

Figures 57 and 58 (wind-up): These are American toys from the 1940s. Figure 57 seems to have been taken from some sort of story, while Figure 58 features a character from the comic strip "Buck Rogers." Sparks fly out the back as the rocket moves noisily forward.

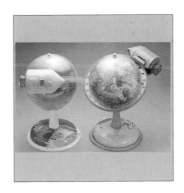

Figure 63 and 64 (battery operated): These toys were made in the 1960s. The satellites orbit the moons.

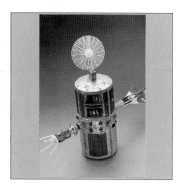

Figure 65 (battery operated): This is a cylindrical space station. It moves forward, the antenna rotates, and a platform emerges. The light at the bottom flashes beautifully.

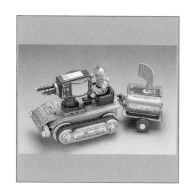

Figures 79 and 80 (battery operated): This space module pulls a car containing batteries behind it. The television camera mounted on the front of the vehicle is also a monitor with changing pictures.

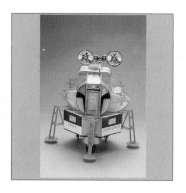

Figure 66 (battery operated): The real thing from NASA was the model for this 1960s toy. The door opens and a stairway for the astronaut appears.

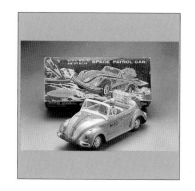

Figure 81 (battery operated): This "space patrol car" is based on the Volkswagen. Elaborate details, including a coil for a bumper, were added to give an outer space effect. This toy was probably aimed at Volkswagen fanatics.

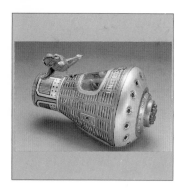

Figures 67 and 68 (friction operated): The Gemini space program provided the model for these toys. The space walk is simulated by the astronaut hovering over the Gemini. Each astronaut displays a different facial expression.

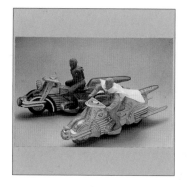

Figures 82 and 83 (friction operated): The rubber dolls on these space motorcycles are rather worn, but Superman is still identifiable due to his cape.

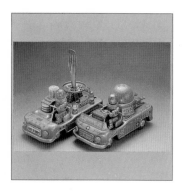

Figures 76 through 78 (battery operated): The astronauts in these examples shake their heads from side to side as they drive. The ball that rises on a jet of air behind Figure 78 demonstrates the weightlessness of outer space.

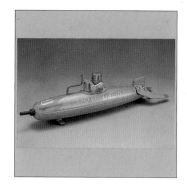

Figure 86 (friction operated): This is a very unusual combination of robot and submarine. The two entities do not seem to go together.

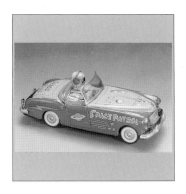

Figures 87 through 89 (friction operated): A sci-fi feel was achieved here by putting astronauts in convertibles or jeeps.

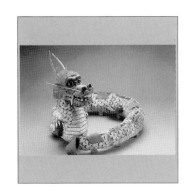

Figure 128 (battery operated): This toy dragon is one meter long. The lights of its tail flash one after another, and it can blow bubbles from its mouth.

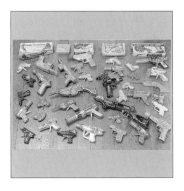

Figures 90 through 110: These are water pistols and battery-operated spark pistols. The battery-operated pistols produce sparks and noise, but none of them fire bullets. The water pistols have a sci-fi style.

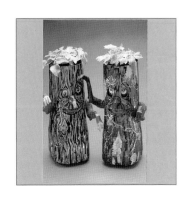

Figure 131 and 132: These wood monsters are very popular in the United States. They can move their eyes and mouths and make a noise like the wind when their leaves are lifted.

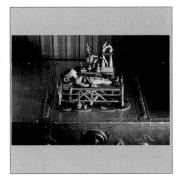

Figures 111 through 122: This series of horror characters was made throughout the 1960s, and is still popular now. One of the chief attractions of these toys is that the buyer paints them himself. They are aimed at adults rather than children because they attract fanatics.

Figure 133 (battery operated): This is a bank. A fortune appears in the fortune teller's hand every time money is dropped into the bank. Its face also lights up.

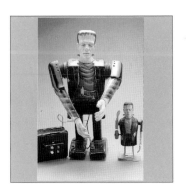

Figures 123 and 124: Figure 123 is battery-operated and notable for its extraordinary expression and realistically jerky movements. Figure 124 is a wind-up.

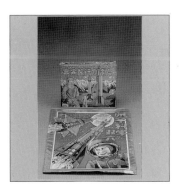

Figures 134 through 142: The theme of science fiction appeared in many kinds of toys. Mars and Venus were especially attractive to the children of the 1950s.

FUTURISTIC DREAMS

I was brought up in the Kyobashi district of Tokyo in the 1950s. Those were the thrilling years of scientific expansion. It was the decade in which the word *science* came to be a word not just for specialists, but for everyone who felt insatiable curiosity about the future and outer space. Today, science progresses at a remarkable speed; it surpasses the comprehension of the ordinary daydreamer. But we who have been entranced by science have a simpler vision, a vision that was captured in the science fiction toys of our youth. These toys fascinate me now because they embody the unknown of that earlier time—they recall the beauty of the daydreams of my childhood.

—*Teruhisa Kitahara*